HERE AND
THERE

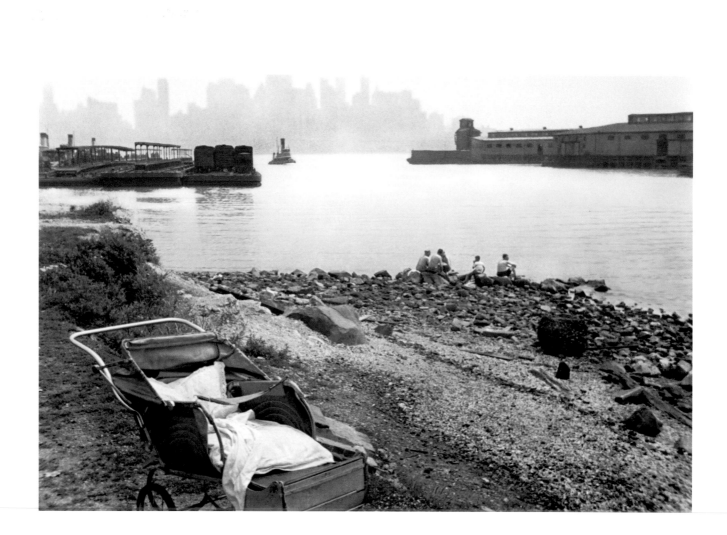

HELEN LEVITT

HERE AND THERE

FOREWORD BY ADAM GOPNIK

POWERHOUSE BOOKS · NEW YORK

NEW YORK is an easy city to paint in, and a hard city to picture. Although more painters and photographers in the last century have burrowed in and made themselves at home in the city than perhaps anywhere else save Paris, the pickings of memorable or perfect images of New York are remarkably slim. Like Florence, it is a city that gives artists a home without offering them a subject. This is partly because New York's unique contribution to the world's art was abstract, but even in pictures that try to make something more of something already seen, we rarely feel the sense of completeness that we feel, say, in looking at a Monet painting of strollers on the Boulevard des Capucines or the Cartier-Bresson photograph of the suited men walking briskly in the Palais Royale — the sense of a whole capital, even a whole civilization, boded forth entirely in the relationship between people and buildings and streets. Looking through a show of New York photographs, we are likely to be struck either by the buildings (lower Manhattan in twilight) or by the people (all those bathers at Coney Island) but rarely by the sublime unity of the two. We have our still lifes and our street lifes, yet little of the life in between that is the metropolitan artist's subject. We sing out streets, but we rarely show them.

Helen Levitt stands nearly alone as a supreme poet-photographer of the streets and people of New York. She *looks* at it, and the accumulated knowledge becomes something less noisy than public love, less declarative and more touching. She even denies, as a New Yorker ought to, having any particular feeling for the city in the first place. Although she is one of the last working artists to survive from the great generation of the forties — James Agee and Walker Evans were simply her friends, and she talks about them as unaffectedly and candidly as we would our classmates — the scale of her achievement is hard to grasp at first, since one of the things it renounces is scale. There is in her work not a single image of the big, symbolic New York. Fifth Avenue, Fifty-seventh Street, the moon above the harbor, the Statue of Liberty, the city in the snow, or even Central Park do not exist for her. This is not to say that her vision of New York — her record of it, she would modestly insist — is not often sordid and gloomy

and pretty goddamn depressing: dead cats and abandoned buildings and grim storefronts papered with last year's fight announcements and lonely guys toting plastic bags and graffiti everywhere you look. But it is never narrowly instructive. There are few homeless people or Bowery bums or drug addicts or anyone else picked out for a moral point.

What she photographs instead is something simpler and much more elusive—ordinary people going about the business of living in a city that is in no way ordinary. The sum of that ordinariness making an extraordinary place. Since at least the nineteenth century the highest romantic image of the New Yorker, birthed by Whitman and graced by Hart Crane and made real by Alfred Kazin, has been that of the walker in the city, the pedestrian with a point, the pilgrim in sneakers. (He, or she, is different from the Parisian flaneur, because the flaneur is walking in a circle, whereas the New Yorker walks in a straight line, on his way from somewhere to somewhere, Brooklyn to Columbia.) In all those earlier hands, though, the walker was his own subject; his soul and dirty underwear is what the walk revealed. Uniquely, Helen Levitt walks and the rest of us are watched as walkers, too. She is the walker in the city with a camera at her side—but looking at its schleppers, and giving them their due.

Levitt's supremacy as a photographer of this island resides on a simple, unpretentious, never-quite-articulated organizing insight: New York is an improvised city, and the people in it live improvised lives. Where her God, Cartier-Bresson, took pictures of Parisians who show off and settle in, her New Yorkers dress up and act out. Levitt's New Yorkers tend towards two moods. One is a mood of indolent boredom and melancholy inwardness. The other is a mood of fierce, even forced, gaiety, dressing up, and holidaying. On the subway they sink into themselves; on the street they step up into a role.

This theatricality is rarely particularly high-hearted or even joyful. It is a function of need as much as desire. This street theater, she shows, is naturally disjointed; we never quite *see* quarrels, or battles, or pitched fights, or even riots or robbery. What we see are small disquieting pantomimes that point

to something else that will happen out of frame: fragments of a play whose first and last acts are elsewhere. Her most casual, snapshot-seeming photographs can therefore become as indelible a piece of casual, found Surrealism as a Saul Steinberg drawing. A tired shoeshine man, on a slow day, sits on the high podium of his shoeshine chair, suddenly at his ease, leg casually thrown over the chair arm—and watches a middle-aged workman with a hat and a ladder and a pail walk purposefully by, the walker's right foot raised like a character in a 1930s vintage comic strip. In the background there are old parked cars and the steel-pen lines of fire escapes and the clear New York sky. Nothing is proven, nothing is pointed, nothing is even poeticized—but from the ease and luxuriance of his pose we sense that he, a shoeshine guy on a slow day, has become an aristocrat for a minute, reviewing a street parade from his throne.

Or look at that fat man smoking a cigar, while behind him the city smokes its own cigar, in the form of a phallic steam pipe shooting white smoke straight up. It is a joke, a small visual pun, and at the same time there is something touching in it: anything that makes a little puff has its little dignity. Levitt pictures, too, a certain vagueness of spirit and purpose that, for all the clichés of New York energy and purposefulness, are built into the city. (When David Letterman first pointed his video camera on the street outside his studio, it was startling because everyone looked so purposeless, so *dazed*.) See, for instance, another man in a hat who carries his two bags of something or other—and where in Paris people carry many small bags, we New Yorkers are always balancing two filled with, well, whatever—and who seems overwhelmed by the ugliness of the twinned steel construction cranes rising above him and all the appurtenances of a construction site around him. The scene is ugly as sin, no anecdote takes place, and yet the dialogue between the walker and his surroundings renders something comic and meaningful about the city: vertical movement here is ruled and ordered and mechanical; horizontal movement is just the rest of us running around.

It would be grotesque, in these two pictures or so many others like them, to say that Levitt "celebrates" New York. But she captures a certain kind of funky soulfulness unique to the city: the repeated incidence of ugliness, the density of awkwardness or weirdness, all of which adds up somehow to a kind of beauty — the kind of local beauty you feel when you say, well, this thing and no other, this place and nowhere else.

<div align="center">★</div>

Helen Levitt is a life-long New Yorker. She was born in the borough of Brooklyn in 1913 and lived there until she was eighteen. Her explanation of her choice of weapon and métier is so startlingly simple that it sounds, it must be, sincere. She became a photographer because she wanted to be an artist and couldn't draw. She was affected by the time and tried to photograph "conditions." Then she saw Cartier-Bresson's work and realized it was better not to photograph conditions, and she started photographing people.

Cartier-Bresson supplied her with both an aesthetic and a practice, and, like all real artists, she took to the practice and let the aesthetic look after itself. She began setting out on foot in the streets of New York on picture-finding safaris that continue to this day. Her favorite places to find pictures were the West Forties, Spanish Harlem, and the Lower East Side. She began to capture, unselfconsciously, the special geography of New York. The long straight streets, the surpassingly nineteenth-century housing stock, all those stoops and tenements and illuminated sidewalks — the odd way that river light penetrates down the streets — she got them all.

She began to "specialize" in pictures of kids not, she insists, out of any special feeling for them. "People think I love children, but I don't, not more than the next person. It was just that children were out in the streets." Levitt's children are the pygmies of the New York jungle, the people who, fearless with the illusion of security from their blowpipes, continue on hunting elephants. No one is better with New York kids, at least as they were until the great sucking-in of television drove them indoors. Children

as a subject are easy to sentimentalize at a distance, easy to treat harshly up close. They are made either sweet or sour, instead of having, as they do, the four great gifts the Buddha wanted in good monks: vigilance, curiosity, magnanimity, delight. Levitt's children chase things, or wonder at things, or dress up. They get wrapped up in streamers and draw cryptic graffiti on tenement stoops.

Yet what is it that sets her children apart from the children of Cartier-Bresson, from those of Boubat and Doisneau? Partly it is focus. "Oh, joy among the ruins," a Parisian once said looking at one of Levitt's street scenes. But it wasn't a ruin at all, just a perfectly normal street along the Park Avenue lines. In the French-Parisian photographers, the force of the past, of a civilization pressing down, weighs upon the faces of their people, especially those of their children. The Parisian kids are learning a world; the New York kids are making one up. When Boubat shows five boys playing Indians in Paris in 1954, there is a note of irony and self-consciousness in the boys' eyes. When Levitt's Harlem boys play gangsters, they're dead serious—almost too serious, given the "conditions:" they are their play. Timidity, irony, a sense of the difficulty of the world weigh down on Boubat's and Doisneau's French children. The New York children make themselves up as they go along. Even in Cartier-Bresson, there is an element of certainty. Cartier-Bresson's famous small boy with his wine bottles is responding to a cultural pattern: he wants to be a grown-up, a man who drinks wine. The press on Levitt's kids is more often the press of the imaginary, the fictive and made-up of show business: movies and television and cheap entertainment. They want to be like in the movies, part of the show. A-Number One, King of the Hill, Top of the Heap.

Look, for instance, at two photographs on facing pages of children in New York. On one, a group of black kids somewhere uptown sits on a stoop in a moment of shared pleasure, in cahoots about something or other—have they been passing the hat for some street performance?—while the eleven- or twelve-year-old in front stands with extraordinary style and grace in his beret and wide knickers. It is an ideal fashion picture, a perfect study of a certain kind of hard-earned African-American slyness and

hyper-awareness. Across the page from him there is a little girl, her hair braided and put in a bun in a manner that seems vaguely Eastern European, crying her heart out. She clutches her throat, her brother jeers; these are not the tears of childhood, these are the tears of hurt and pain that is the first education we get in the truth that life socks it to us all, eventually. A seized image of high style, followed by a sad snapshot of early sorrow, its proximate causes and eventual effects ("And then she stopped crying and ran off to play…" and "She was never the same again…" are both plausible next sentences in the story) are lost to us. What we remember here is the moment — not the decisive moment; rather, the suggestive moment, the moment between the acts. When we look at a Levitt we rarely ask, "What will happen next?" but we almost always ask, "And what did he feel like just then?"

<p style="text-align:center">★</p>

Helen Levitt has chosen to end this survey of a life's work not with the city, but with one of the half-dozen pictures taken outside of it — a line of animals, mismatched but marching on, on their way somewhere. And there is, the viewer thinks, something animal-like about her people, her characters in New York; they have a barnyard candor and competitiveness and consistency. The pony and sheep look like honorary New Yorkers, coexisting.

 This stoical acceptance, this refusal of the obvious clichés of humanist "concern," gives her documentary work at once an odd impassivity (she is never contending for anything) and a certain lost and elegant calm. The documentary role of art is slighted now; we no longer believe in the open-minded record, and our art conspires against the notion of factual truth as an aesthetic in itself. Looking at Levitt's work, we are inclined to defend it by insisting that it is something more than documentary, more than "journalism," the product of far more than a meaningful and lively walk: we talk about the casual beauty of its design, the integrity of its vision. And this is surely so. She's an artist, and even her

occasional de-peopled street pictures have the same flavor as the pictures of her great abstract contemporaries — the same taste for the scratchy, unkempt crowded little biomorphs you see in great early de Kooning, like his "Attic;" the same belief that the unprepossessing, packed close, made for something muscular and artful. (There is, too, the same love of graffiti, as unspoiled vernacular drawing.)

Yet the longer one looks at the pictures the more one feels that what counts in them is their candor, their simple documentary facility, their — you should forgive the expression — truth. Life in the city is like that. For one brief shimmering moment in the 1990s, to be sure, when New York was clean and bright and odorless, Levitt seemed, like Whitman, part of the city's lyric, street-poetry past. But life took its customary plunge, and we find ourselves back in her city again. We are limping along — in our undershirts. And yet, in a city newly fragile and vulnerable (two words one never before associated with it) her vision of the city feels more necessary than ever. "I see buildings and water," the attendant on one of those doomed flights is said to have cried as the plane came over the city, and, for anyone who cares about New York, it remains a terrifying and heart-sickening and important phrase: our city is simply buildings surrounded by water — and people in between. New York, seen from the air, or from any kind of distance, is just buildings and water, a mad and grasping grove of concrete and water running around it, with bridges. No greater theme exists than the real lives of the people who, against all odds and, increasingly, against common sense, clump in the shadows of its skyline. When people, a century or two hence, want to know what it felt like to live here and there in that valley, they will turn to Helen Levitt's photographs to find out.

Adam Gopnik · New York · December 2002

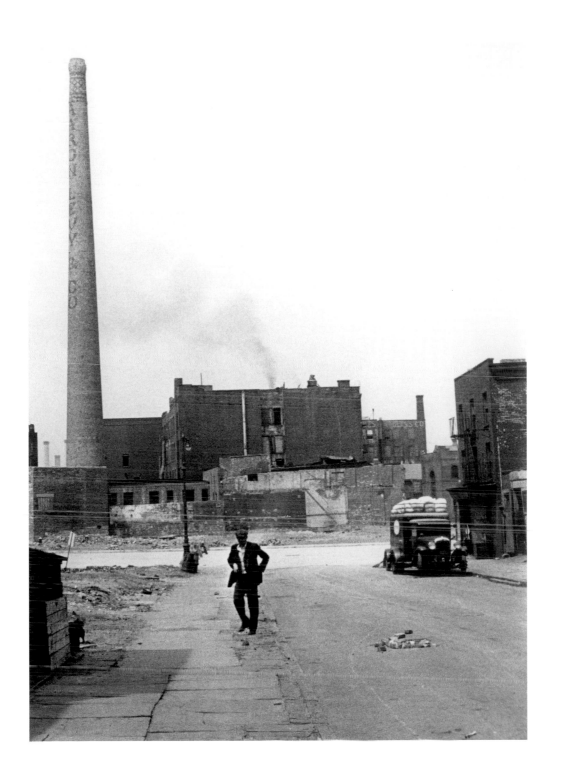

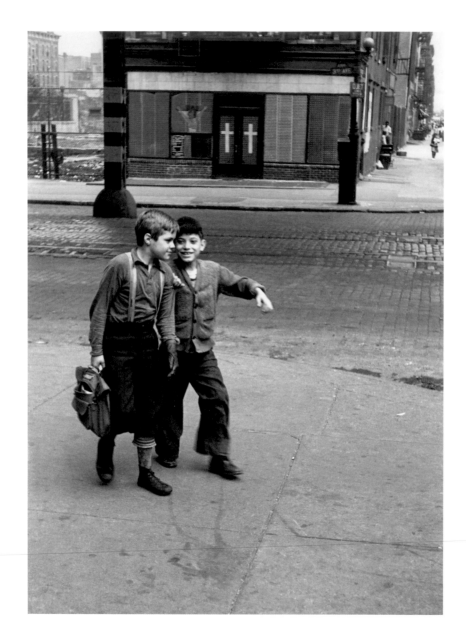

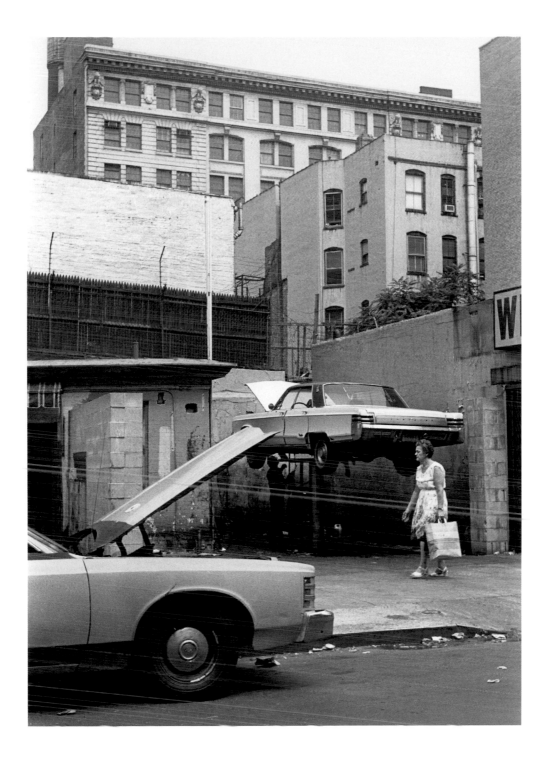

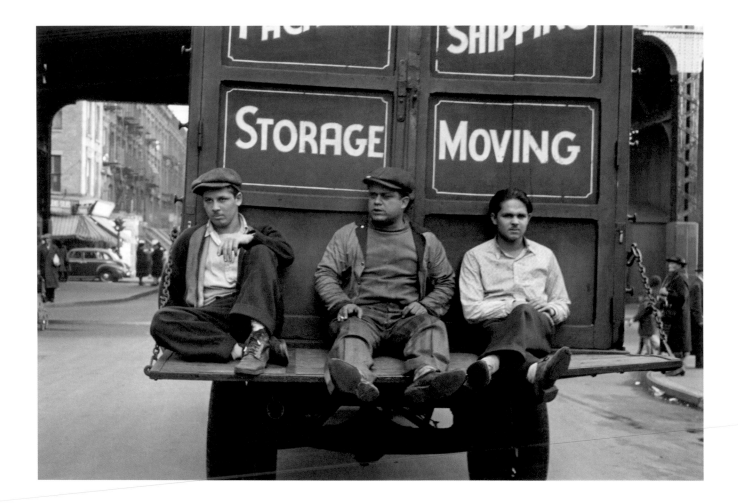

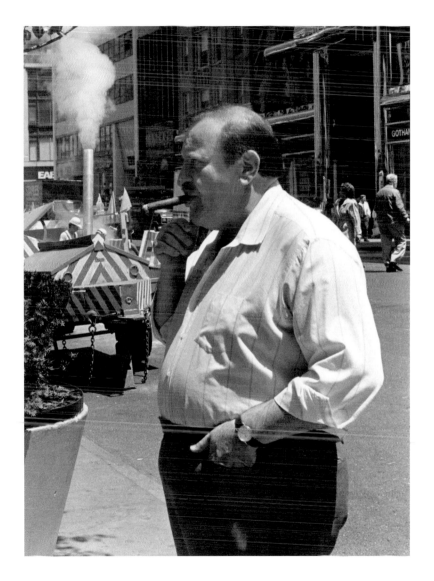

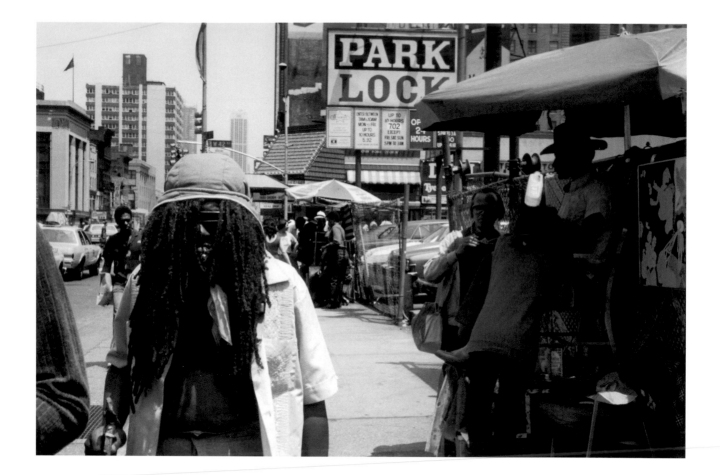

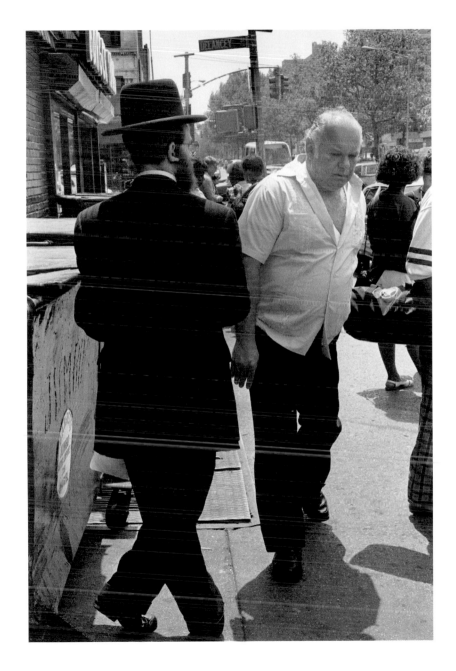

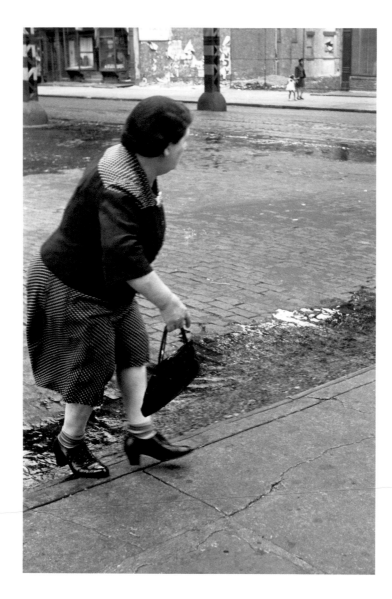

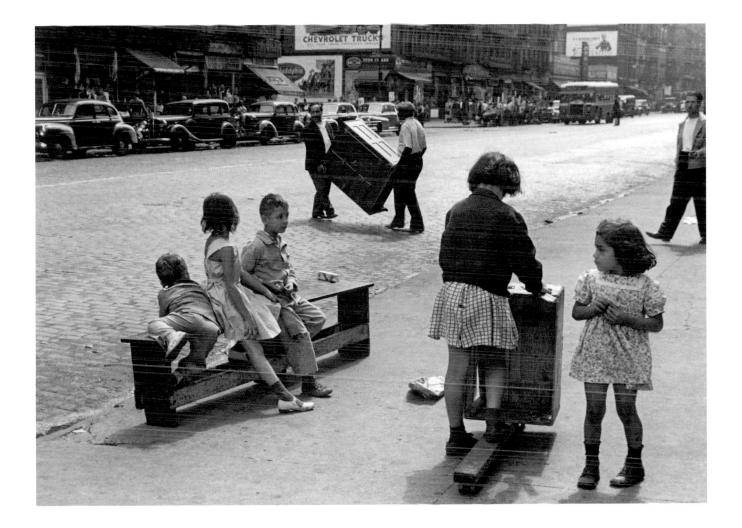

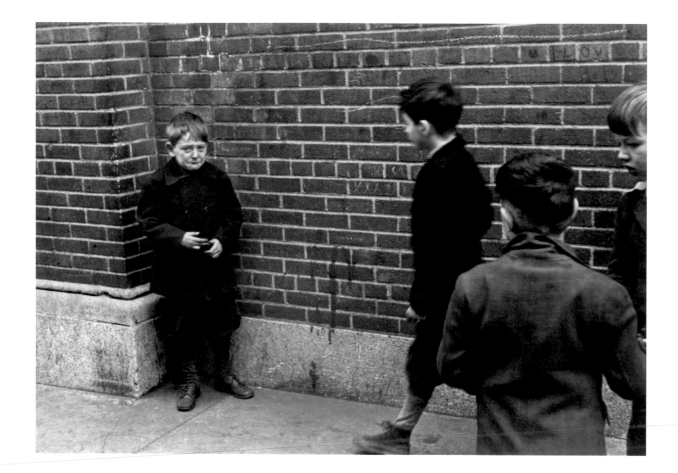

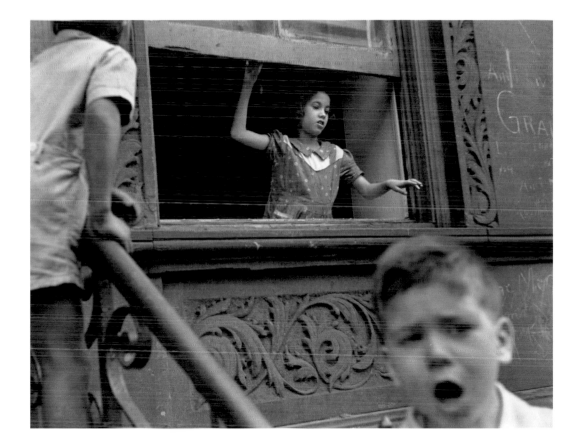

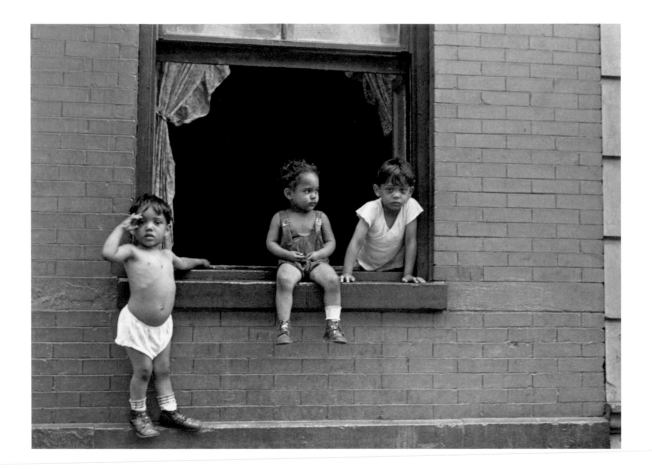

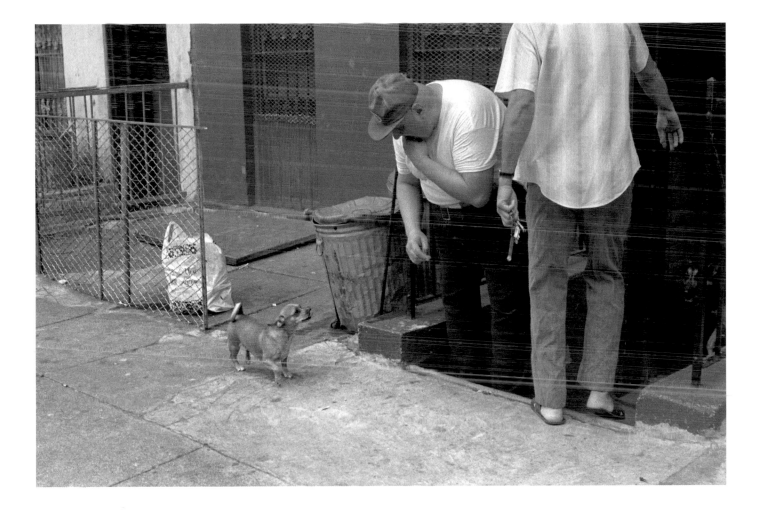

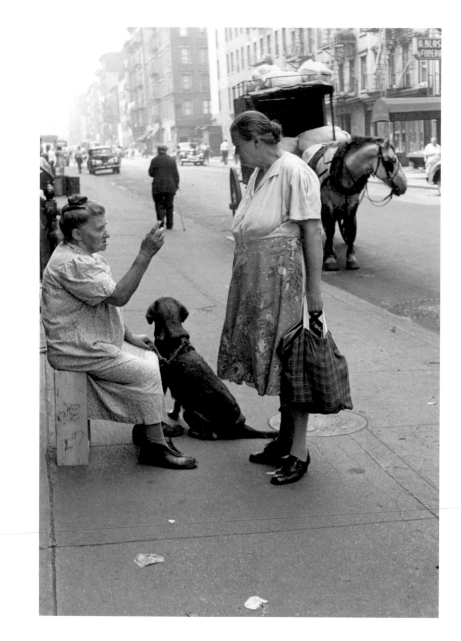

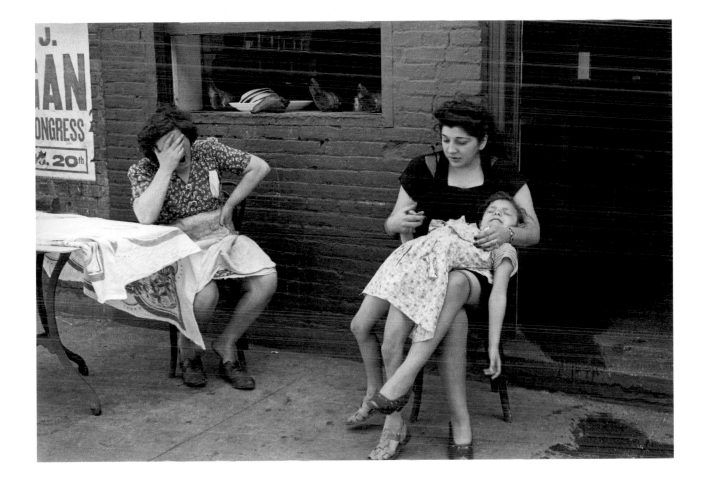

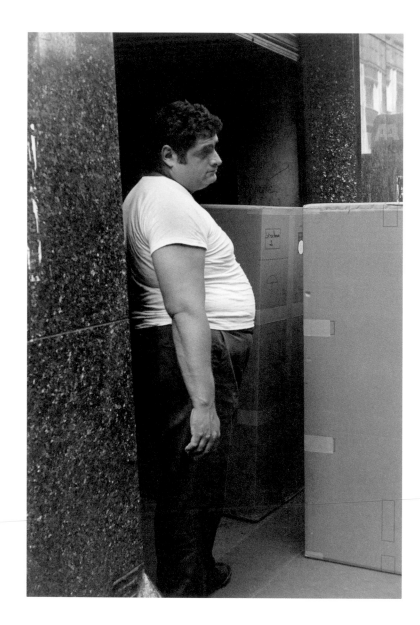

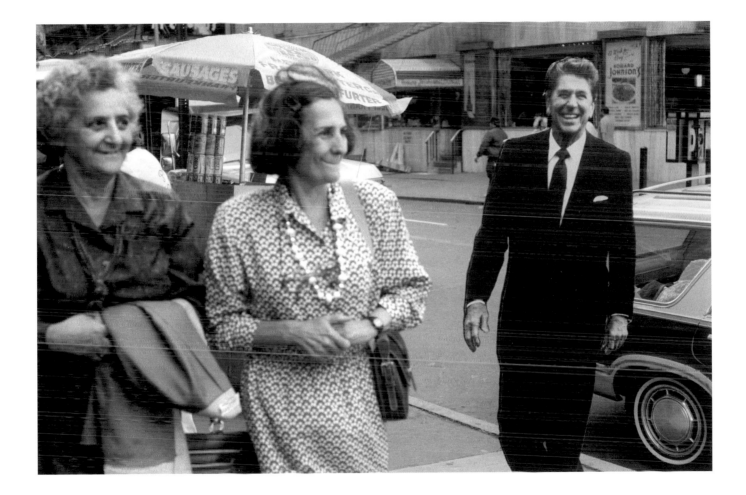

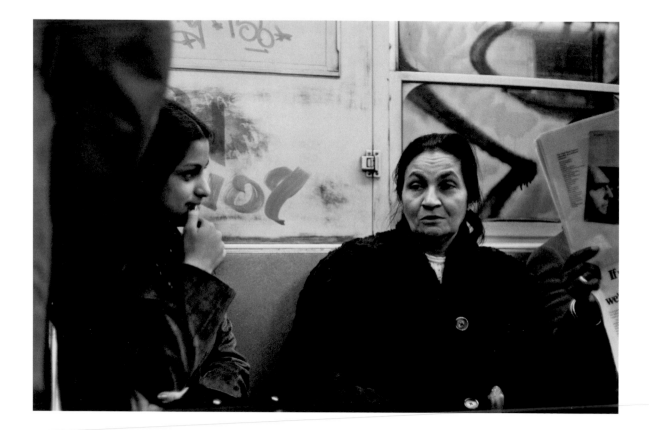

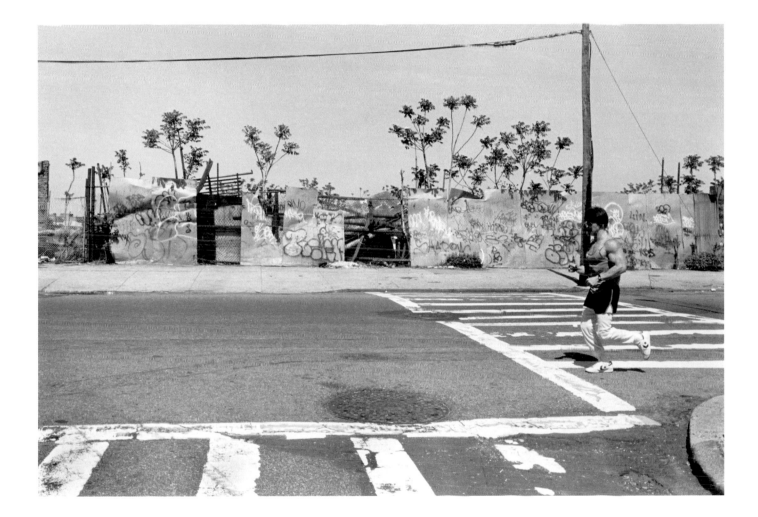

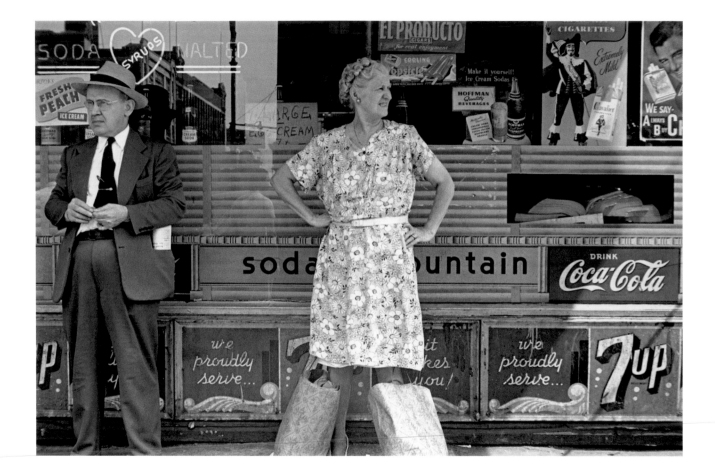

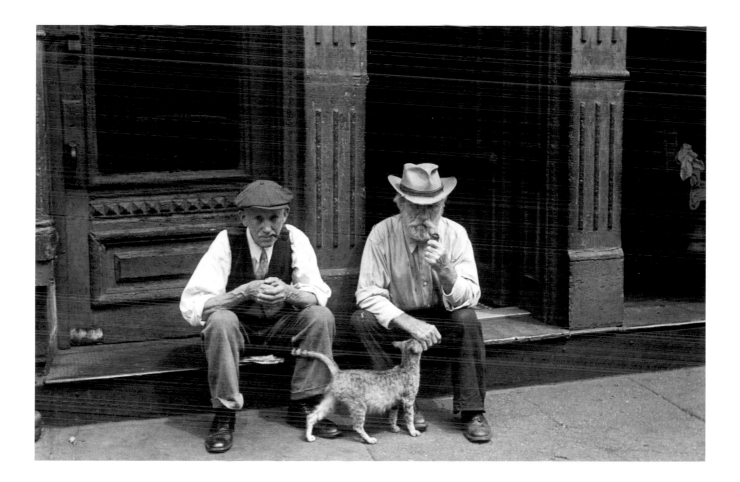

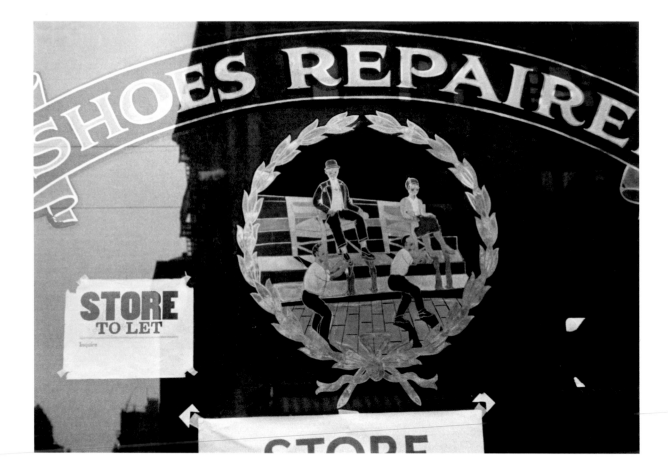

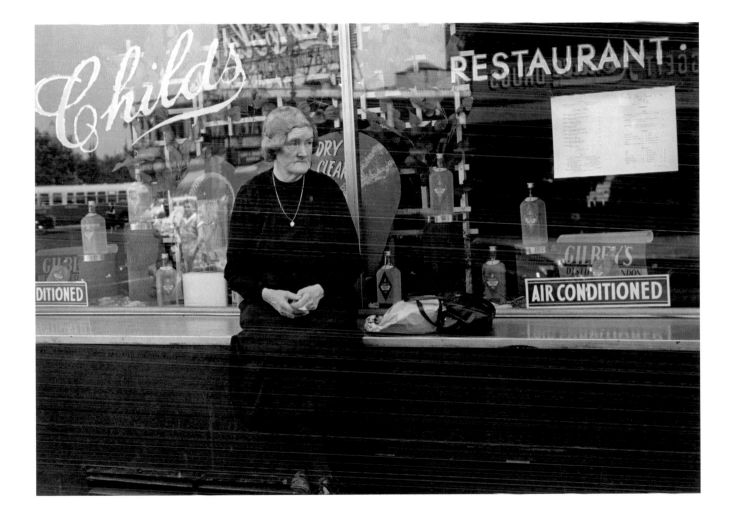

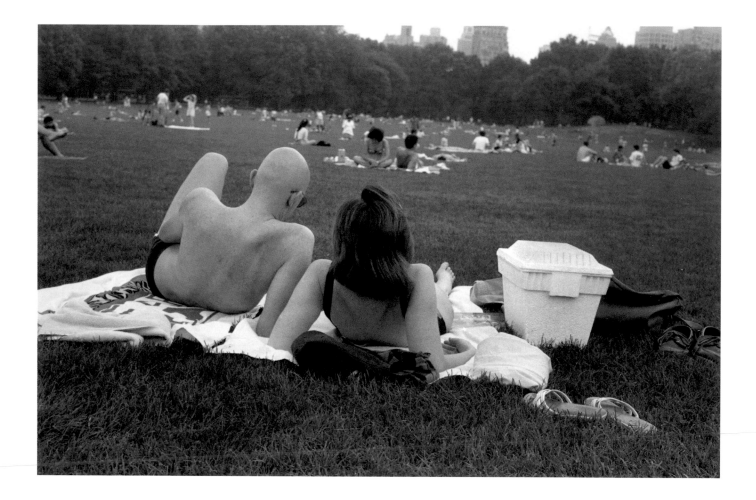

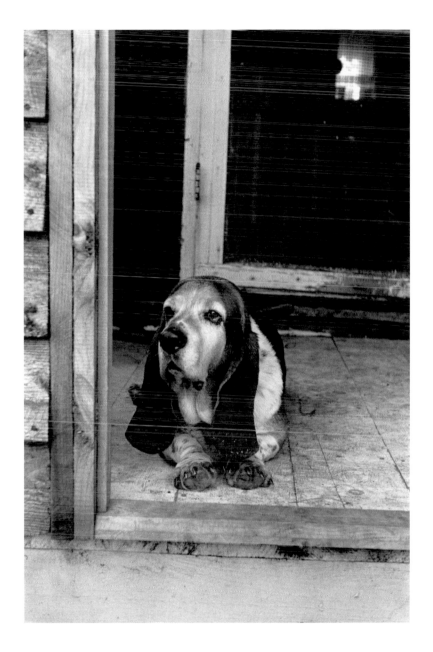

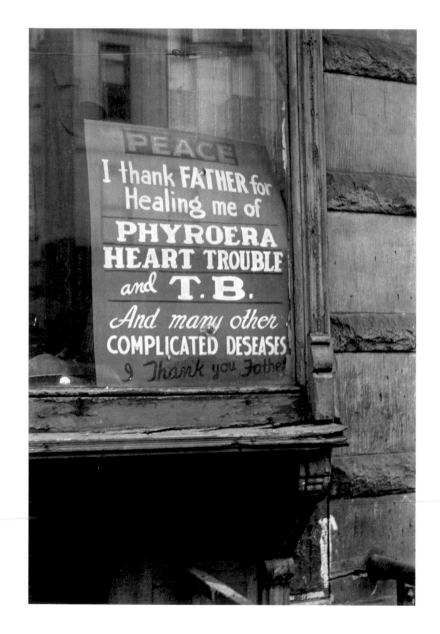

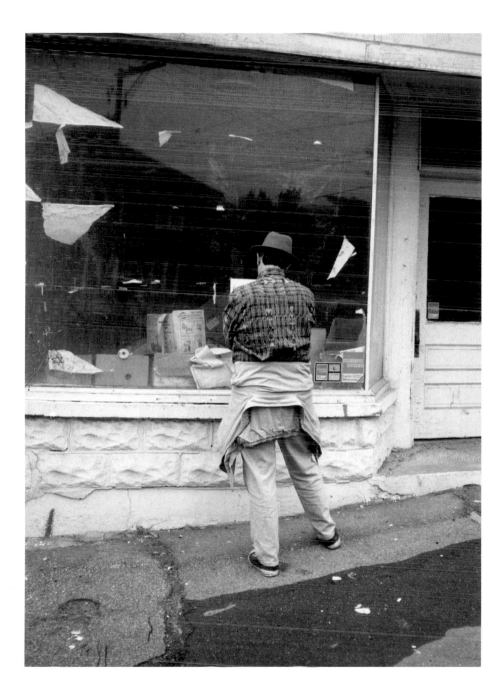

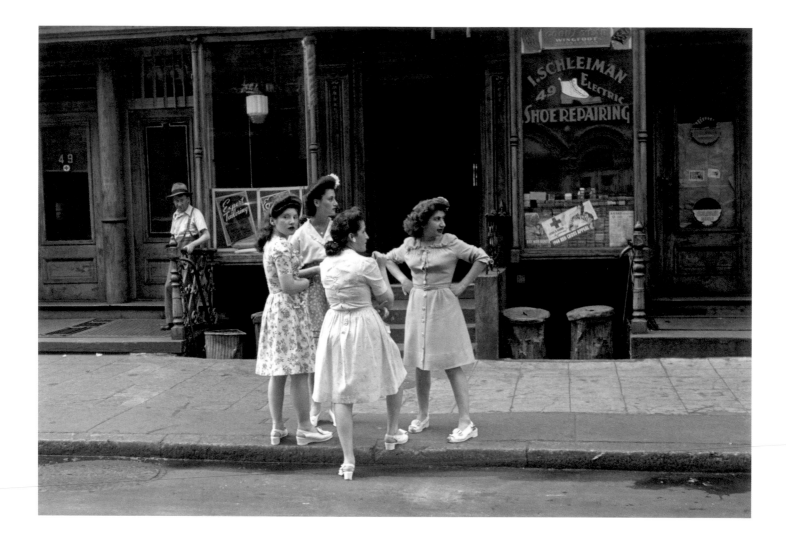

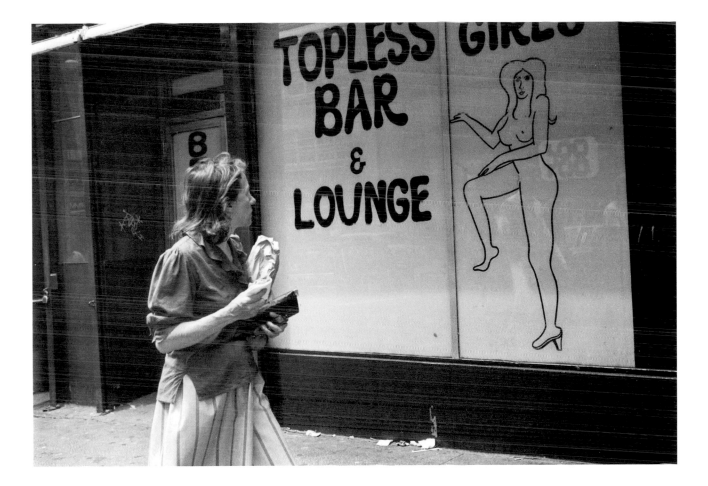

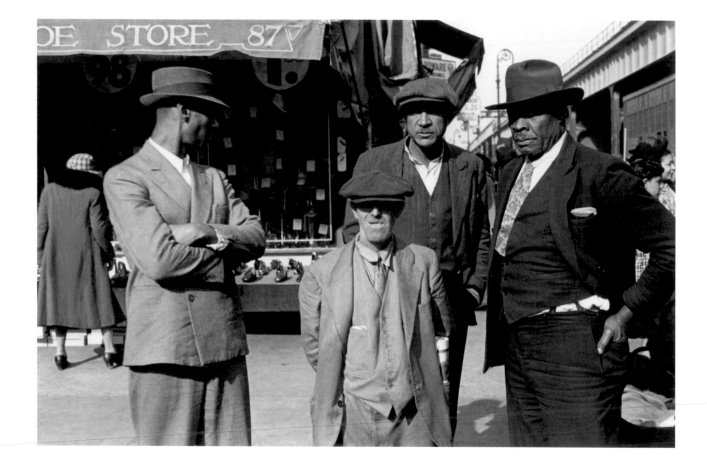

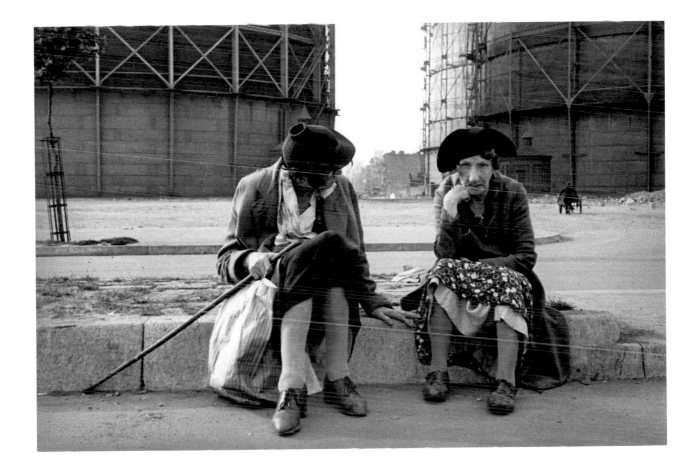

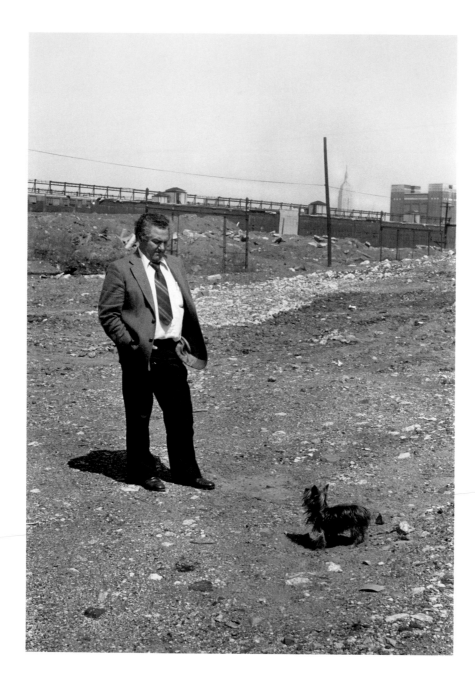

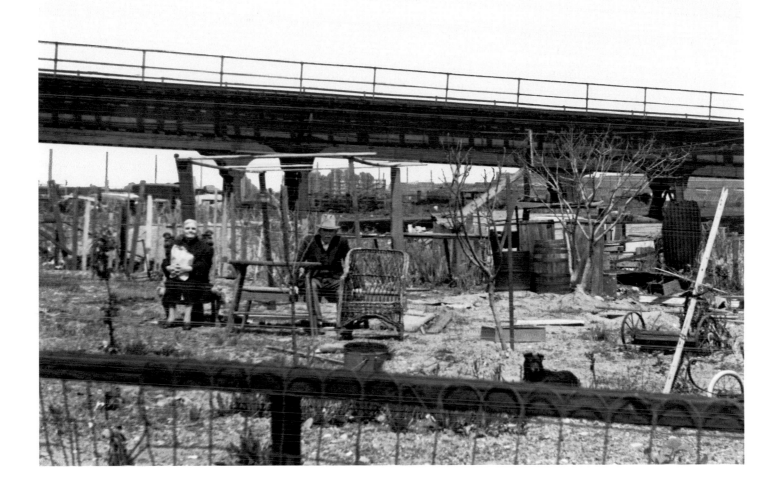

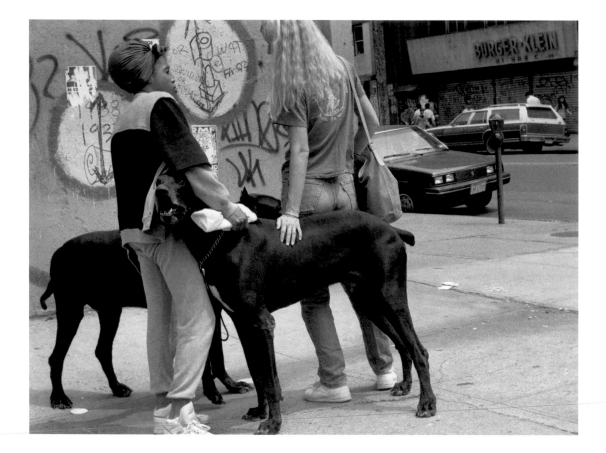

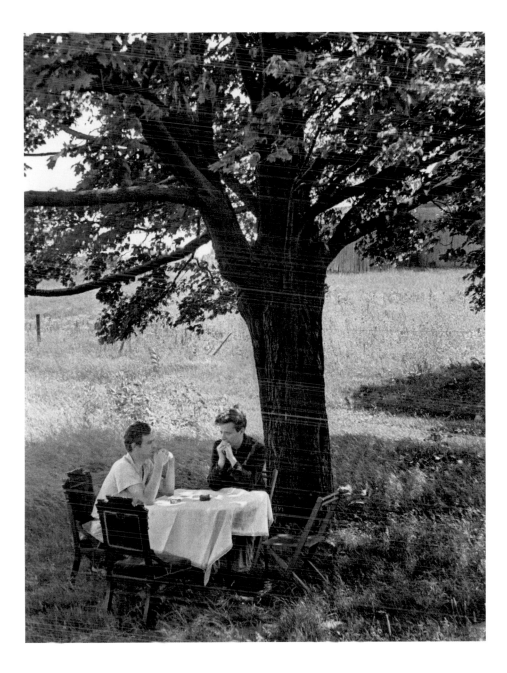

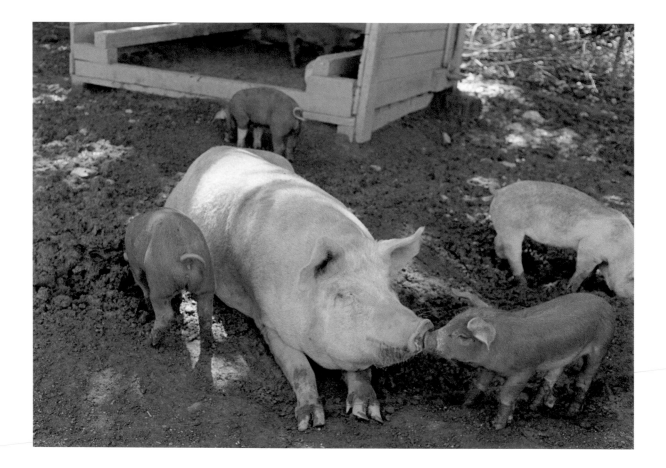

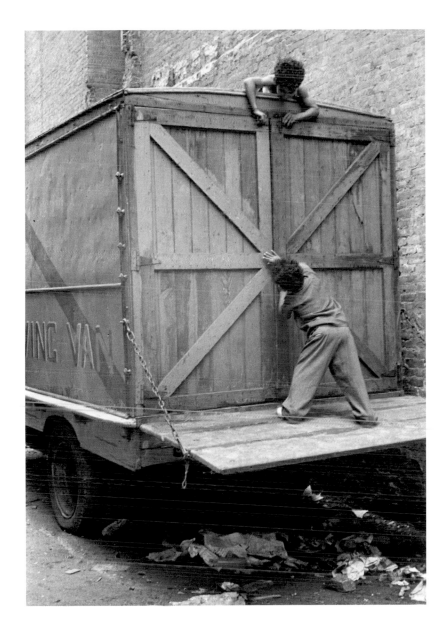

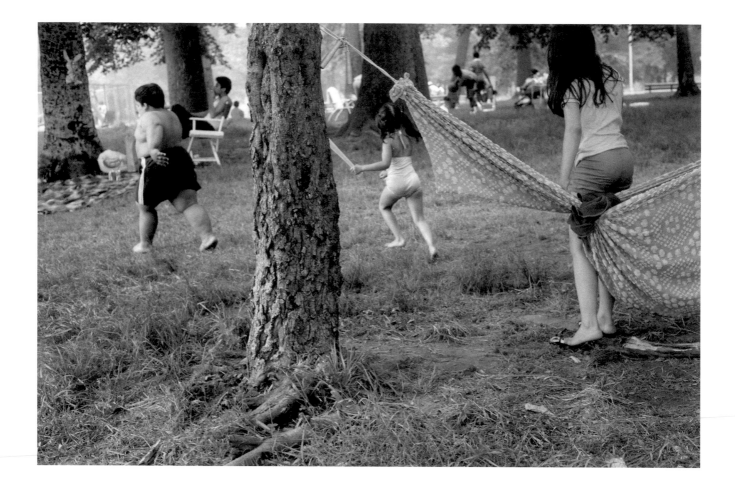

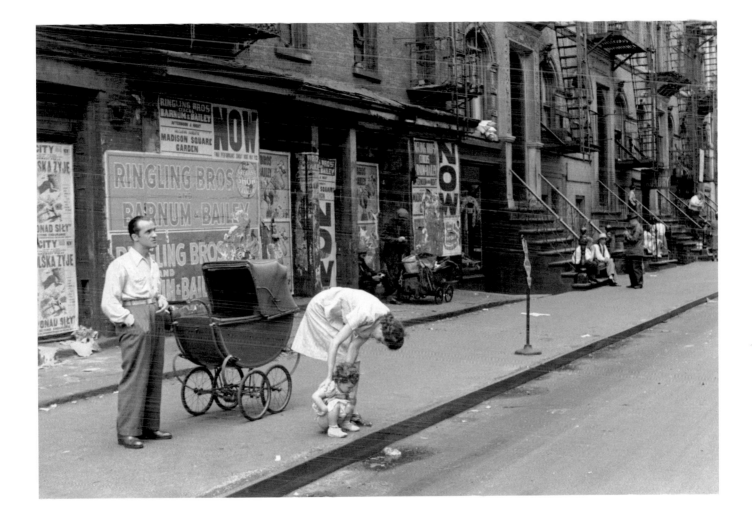

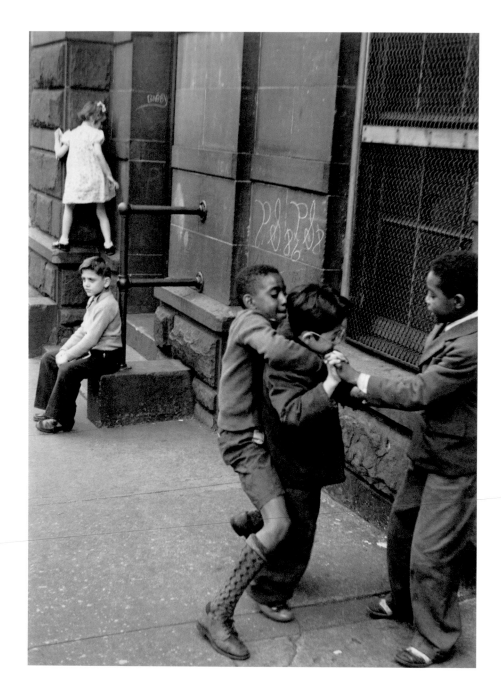

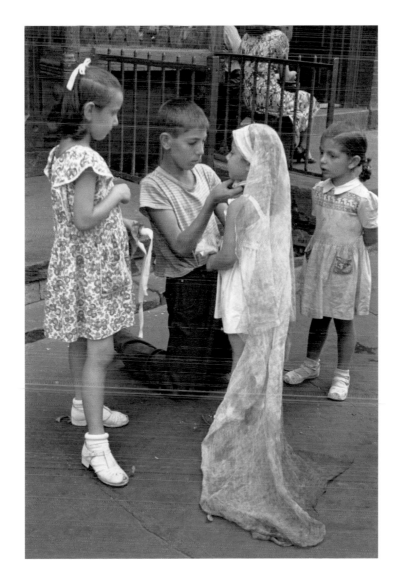

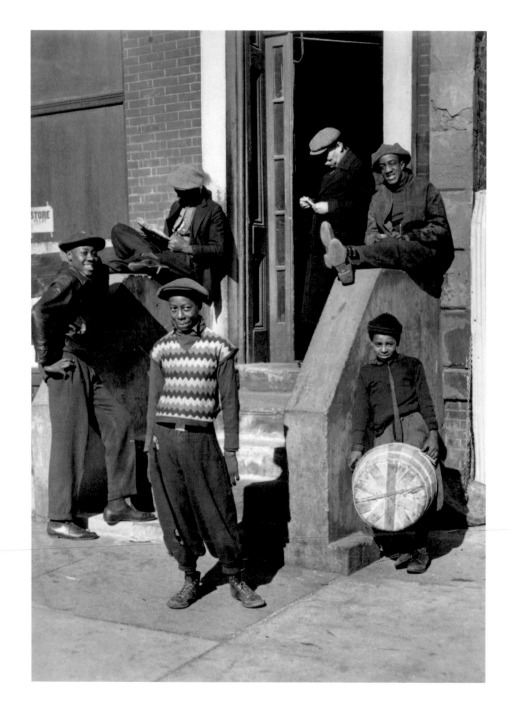

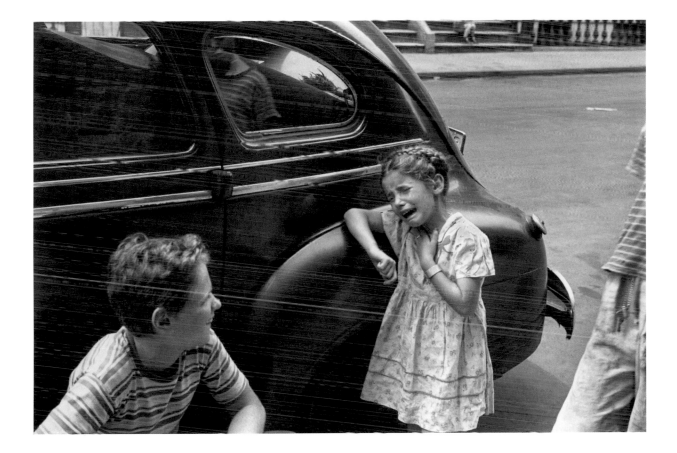

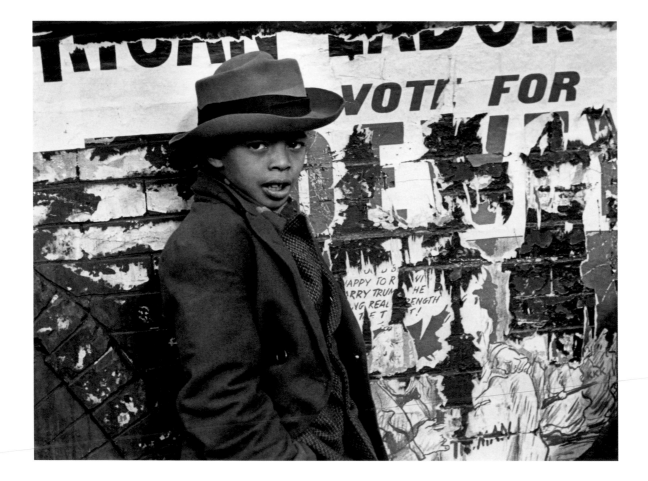

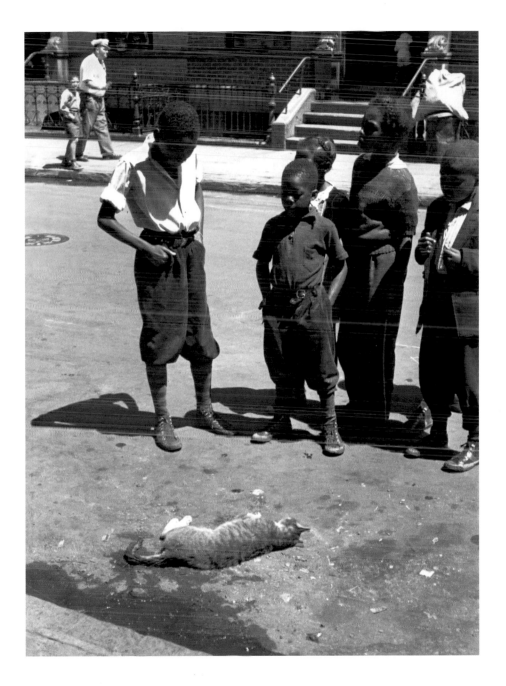

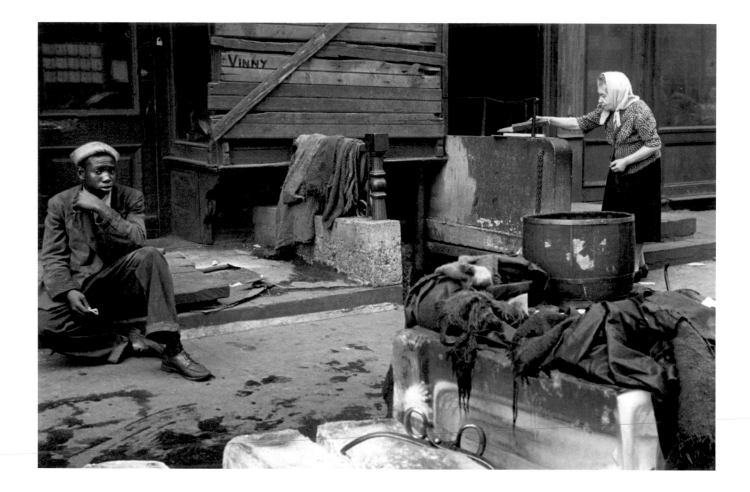

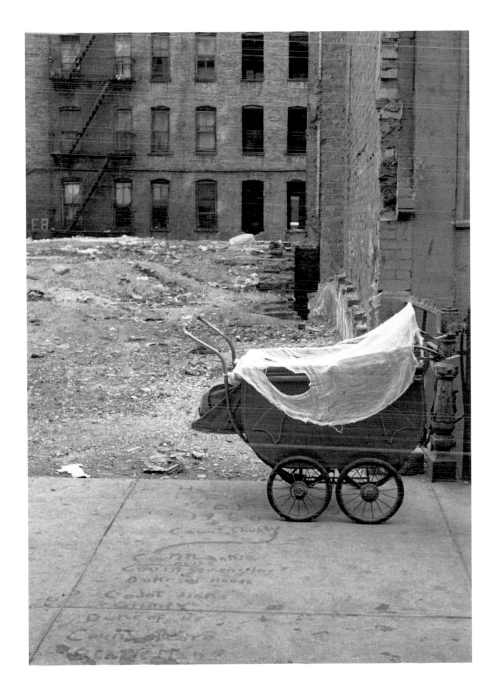

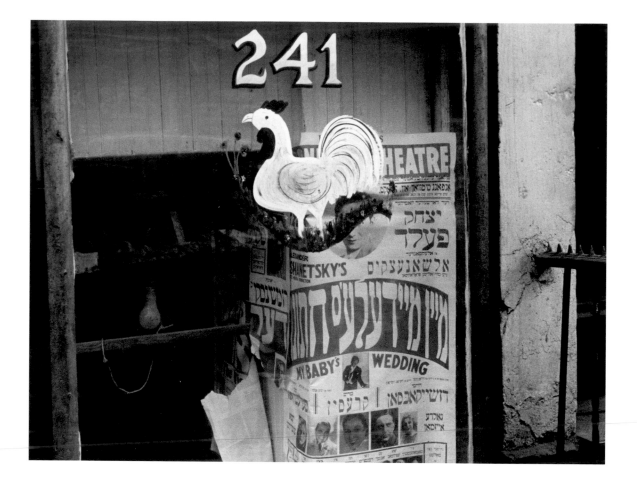

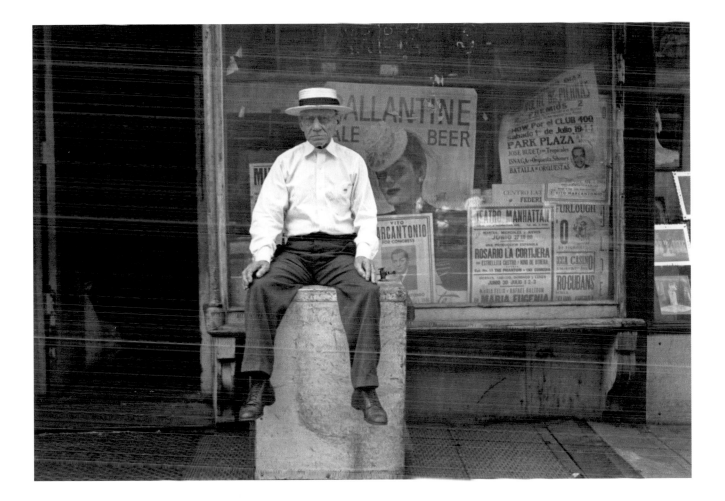

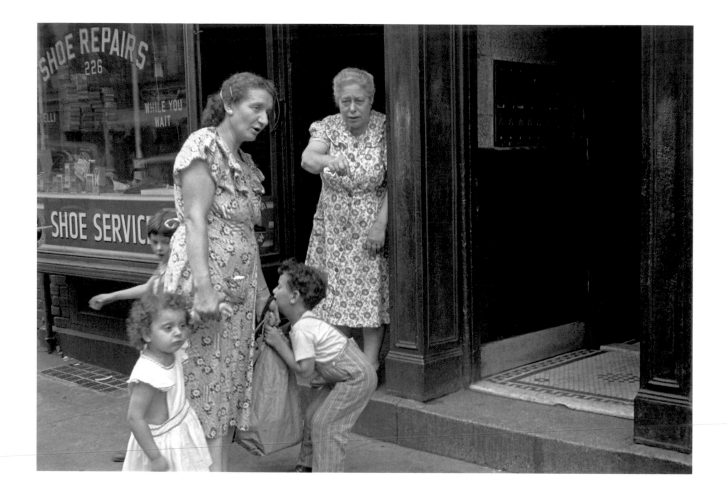

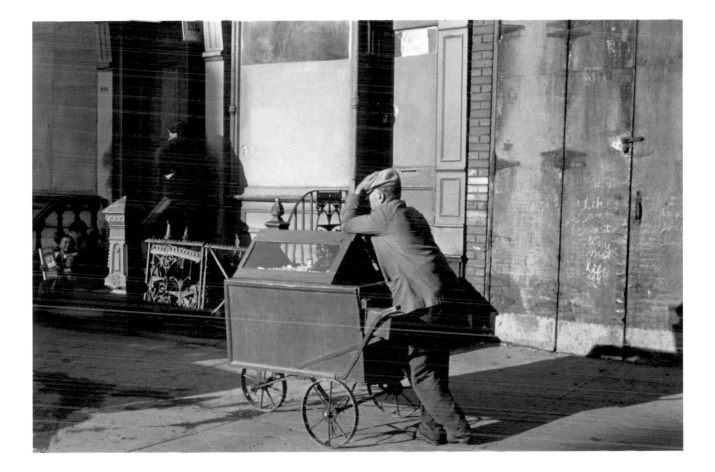

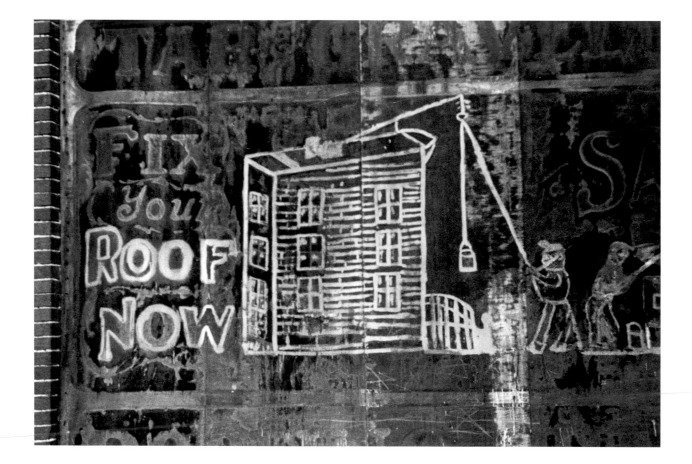

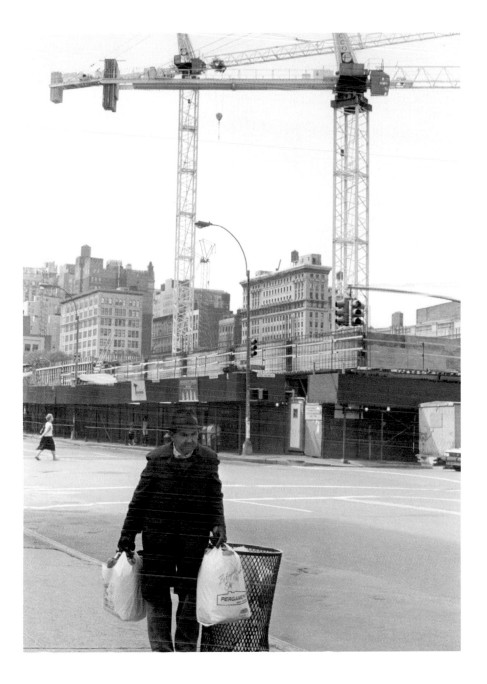

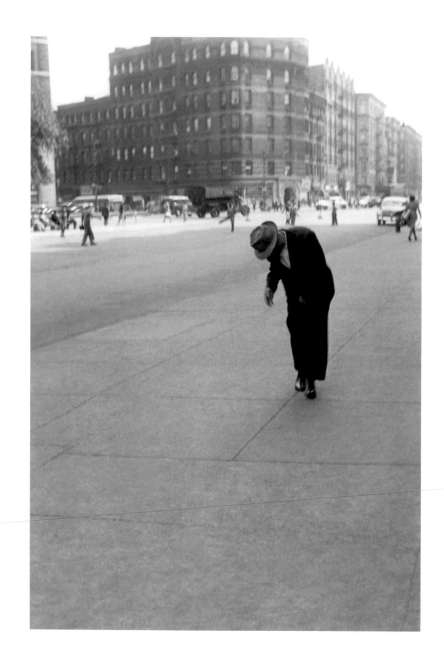

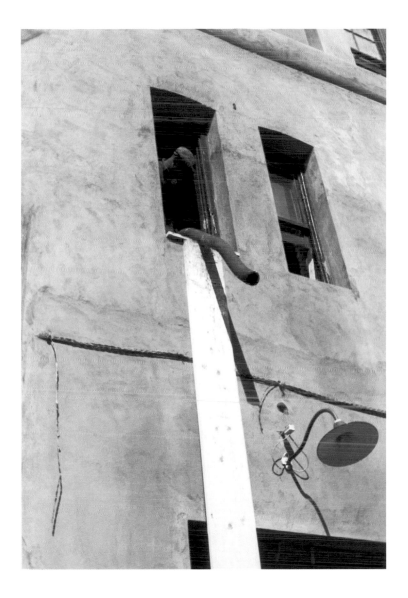

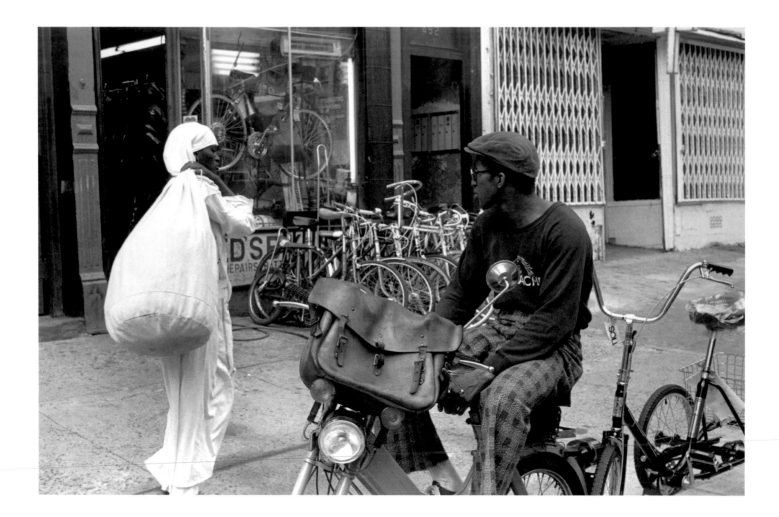

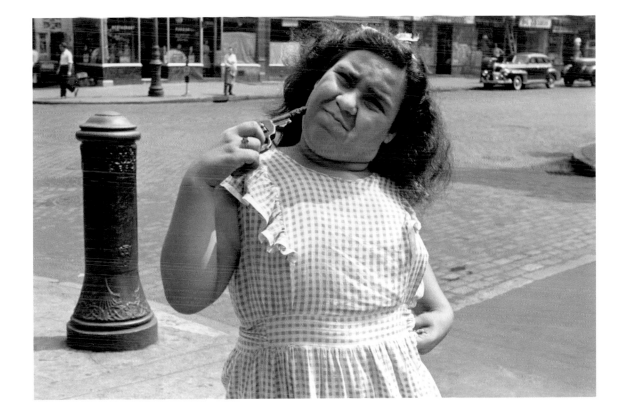

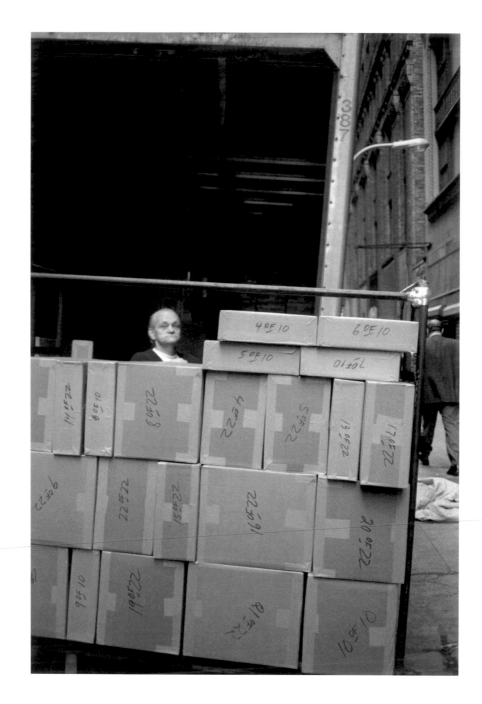

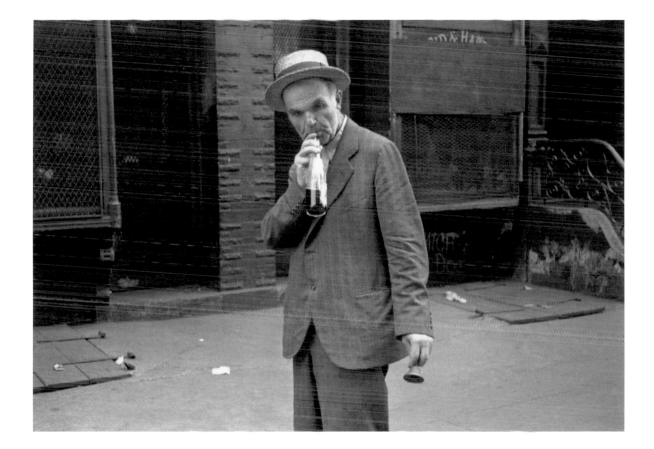

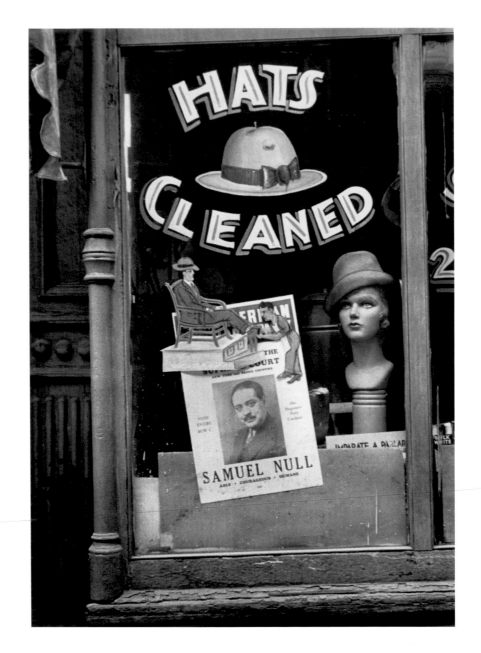

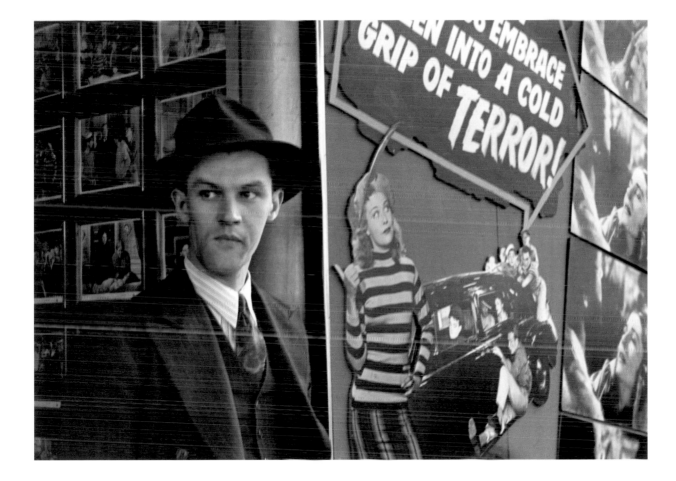

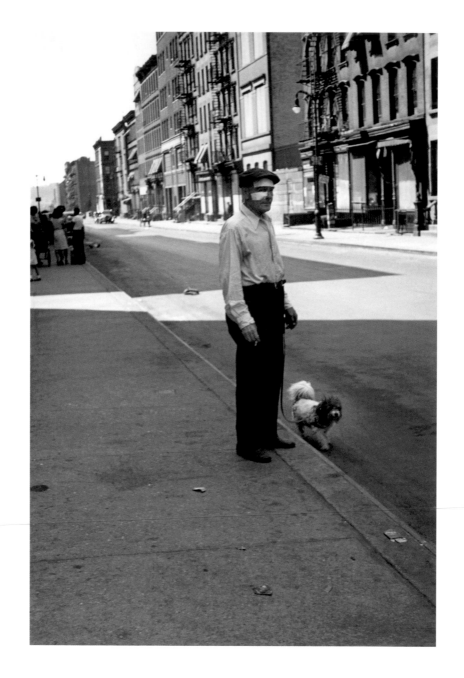

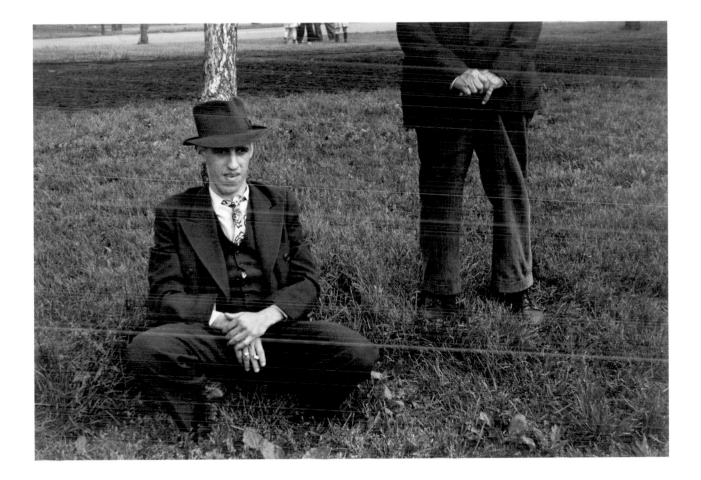

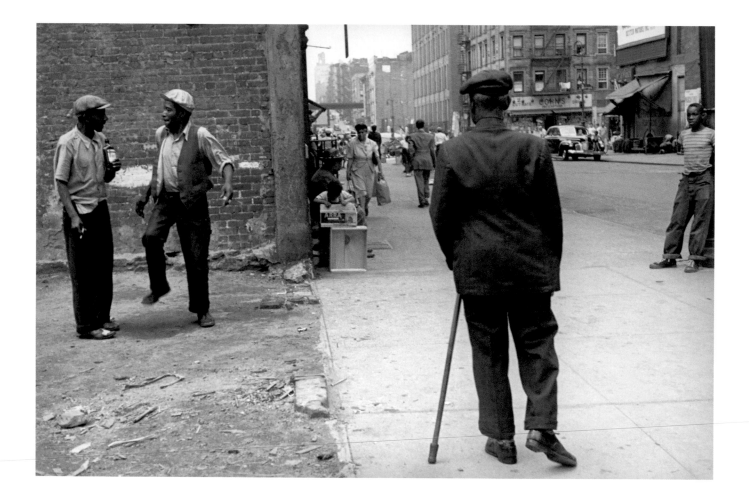

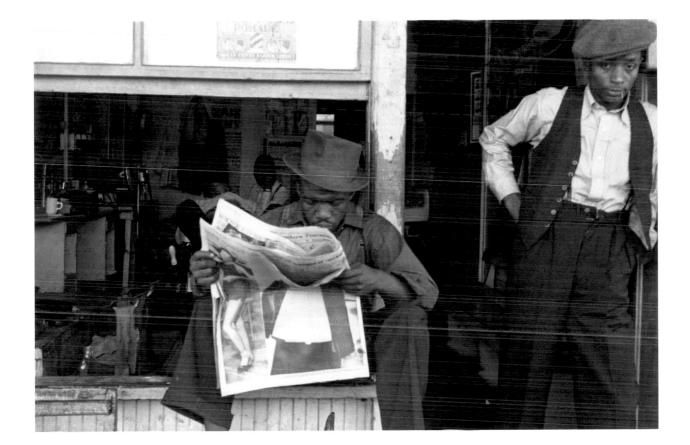

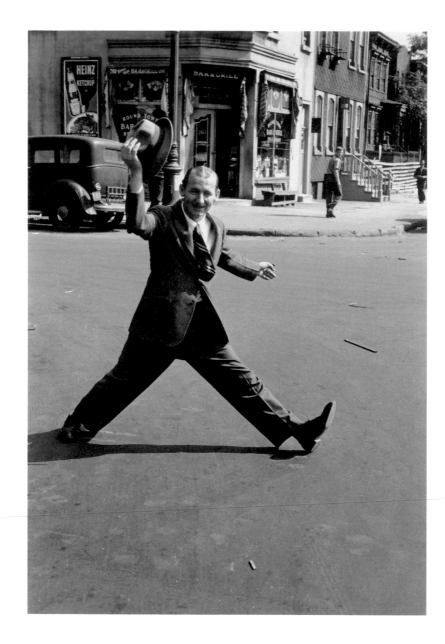

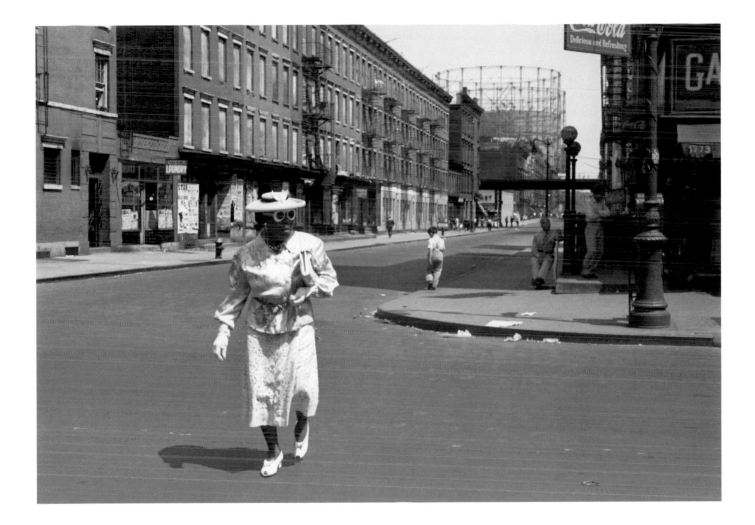

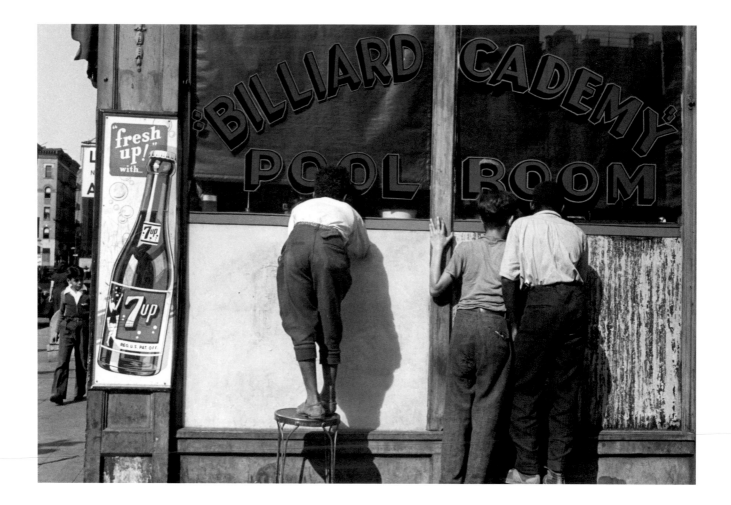

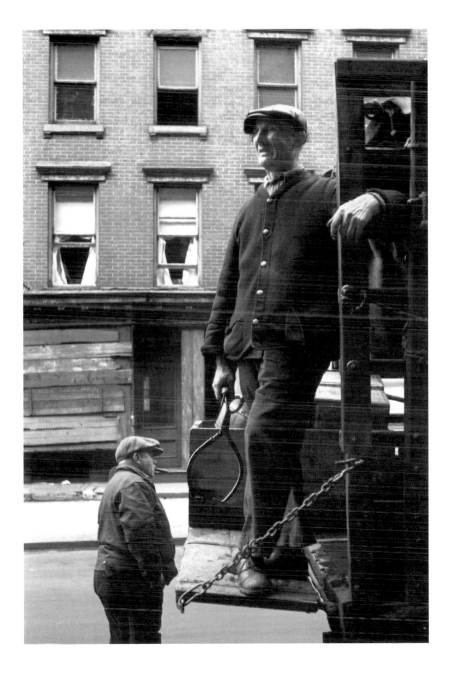

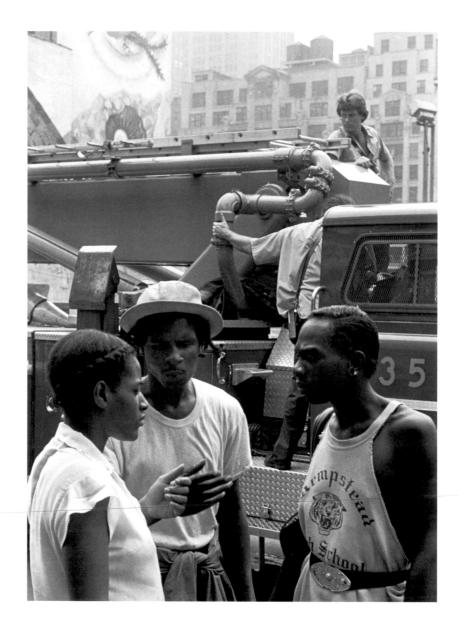

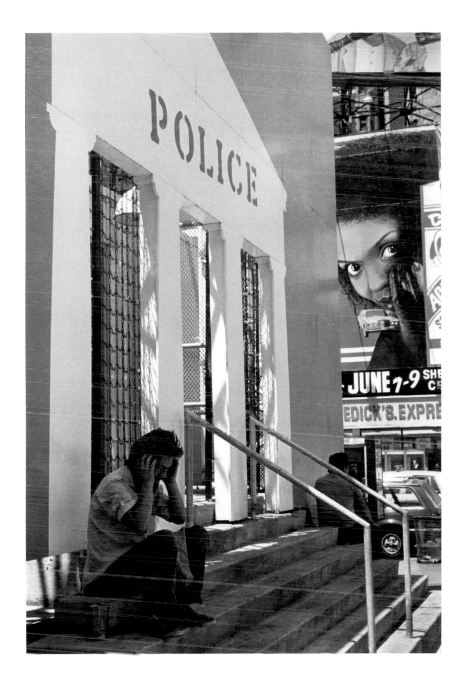

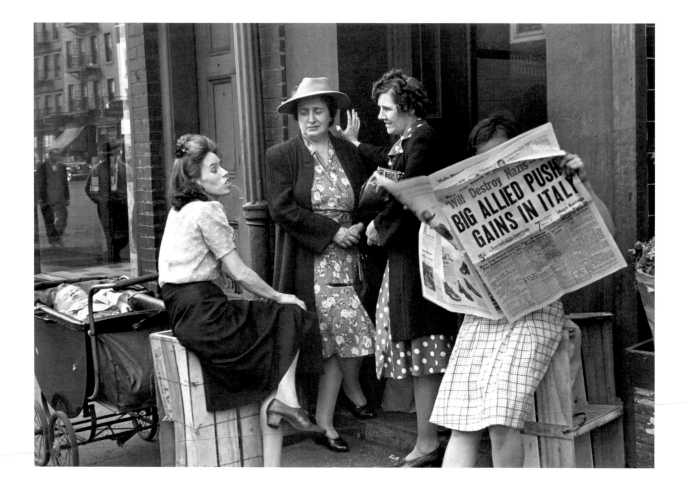

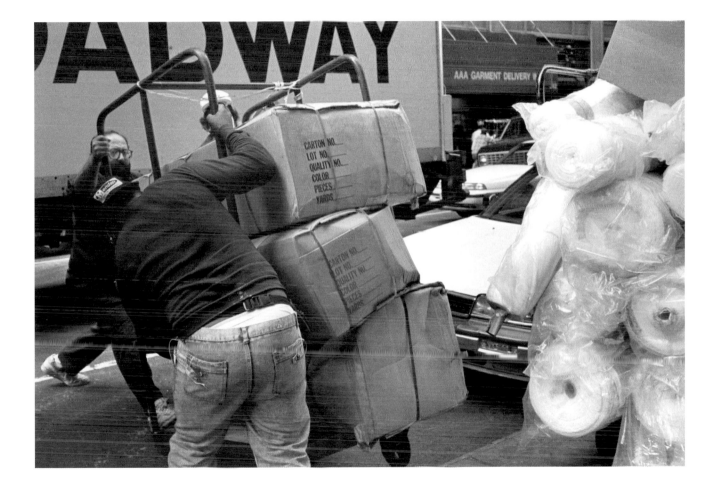

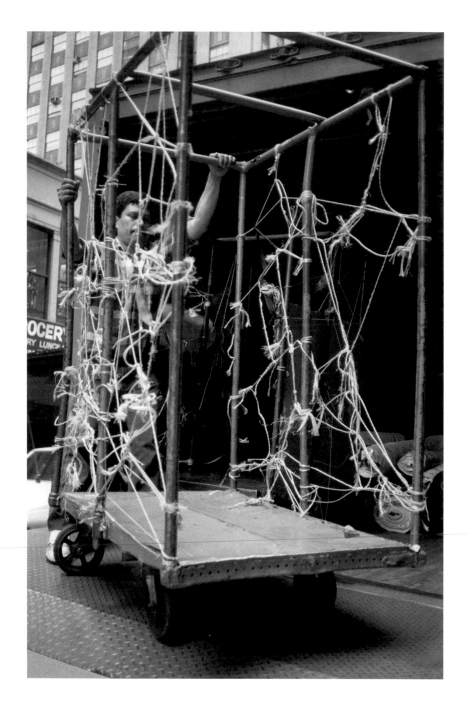

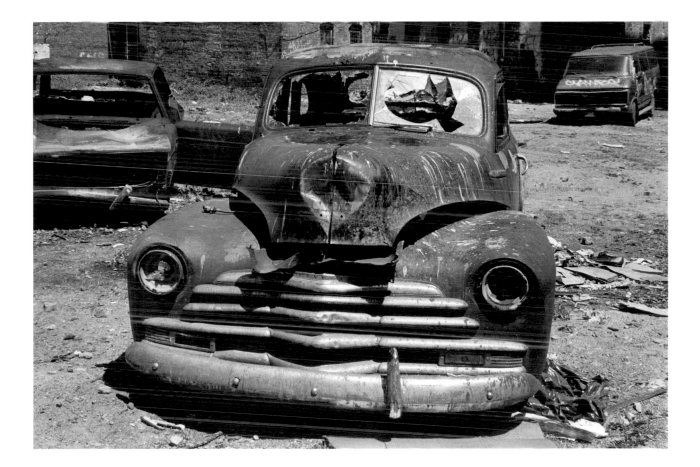

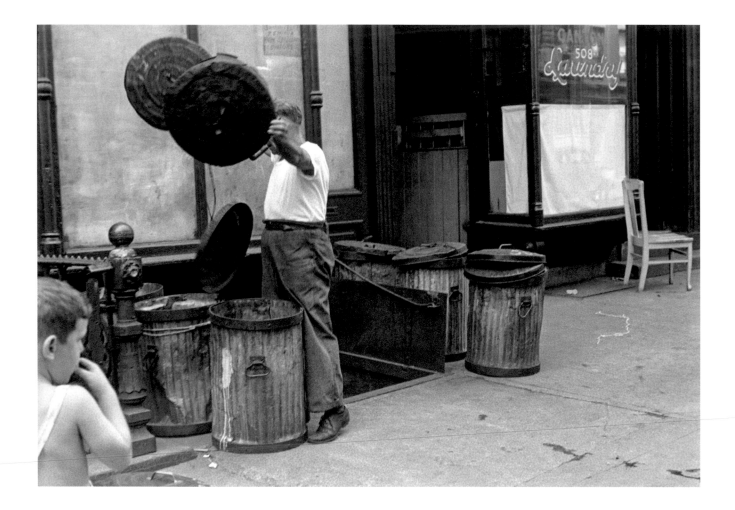

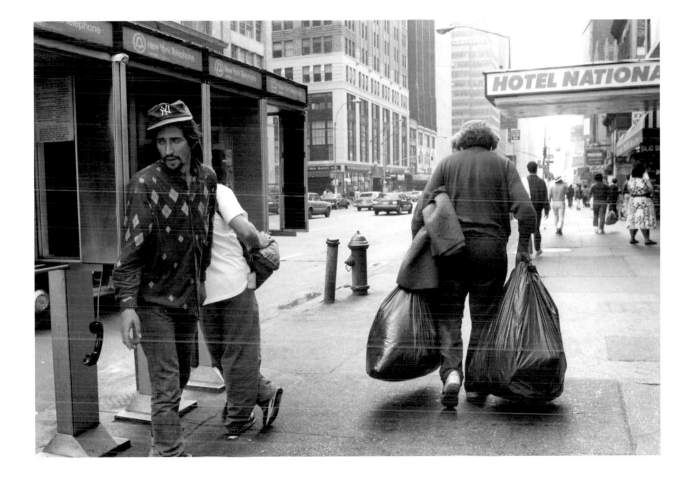

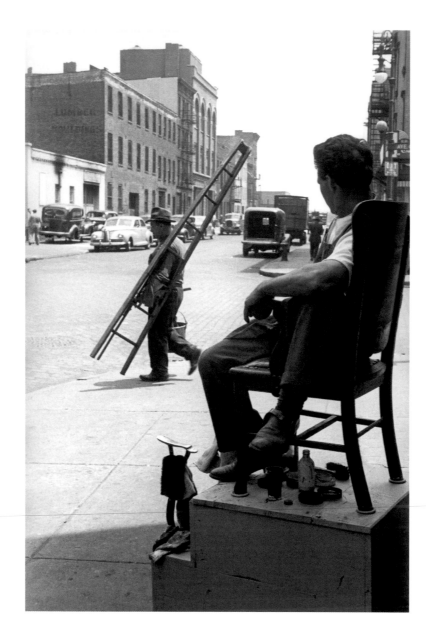

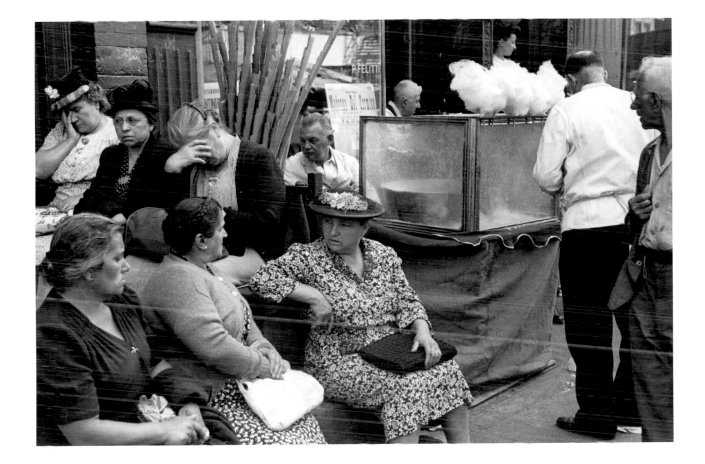

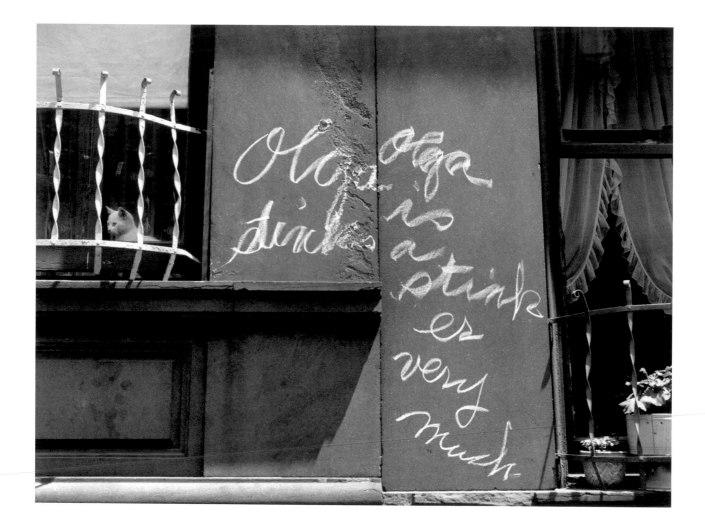

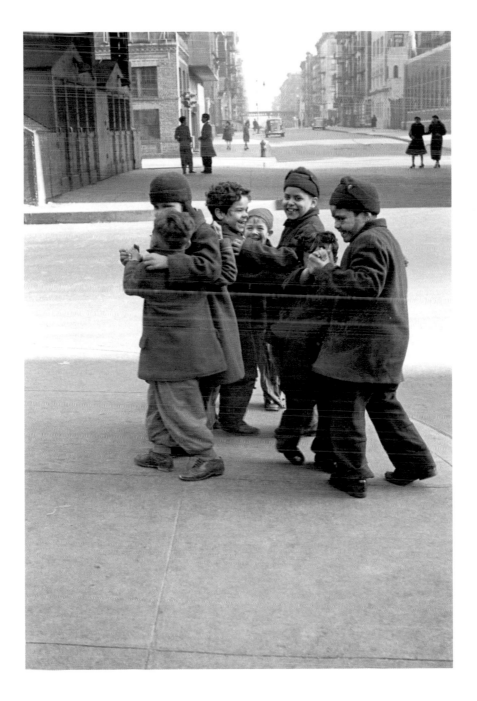

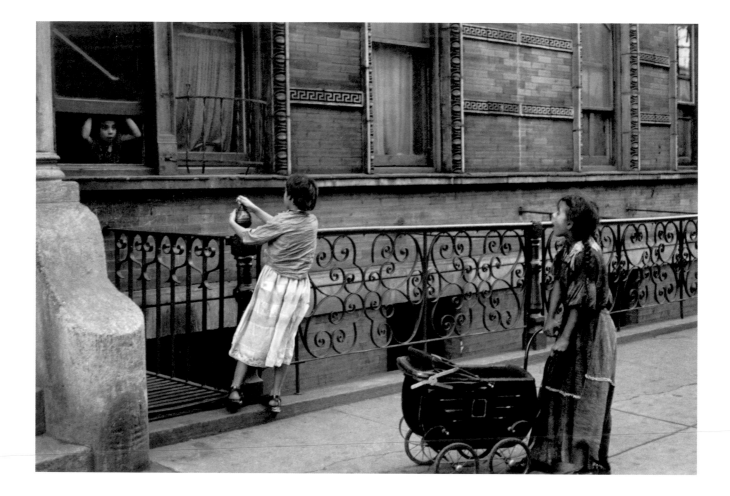

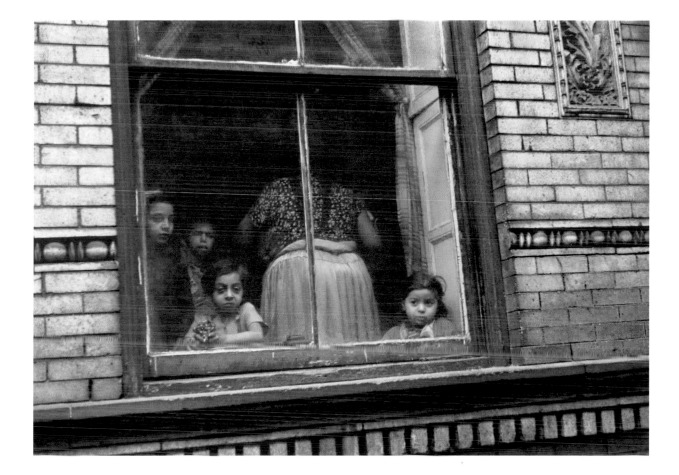

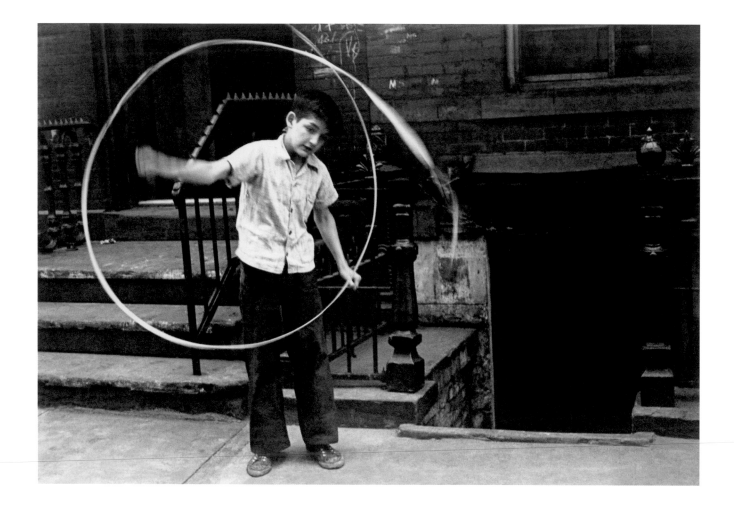

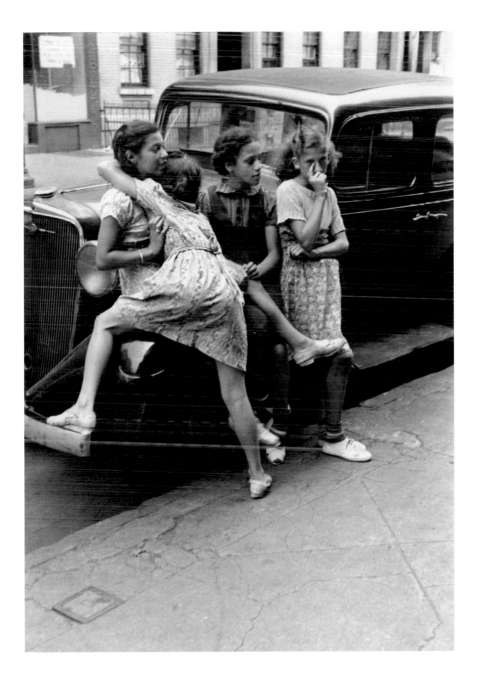

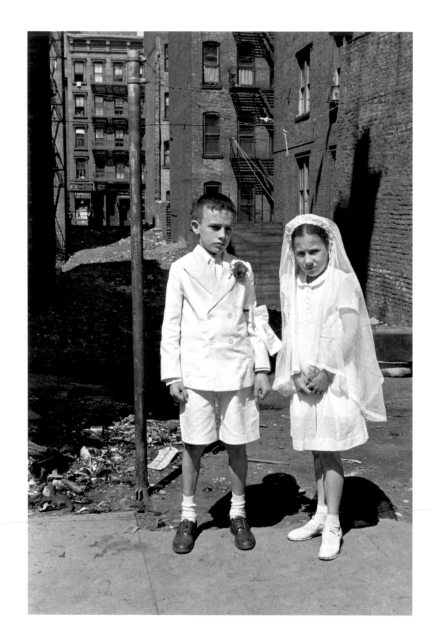

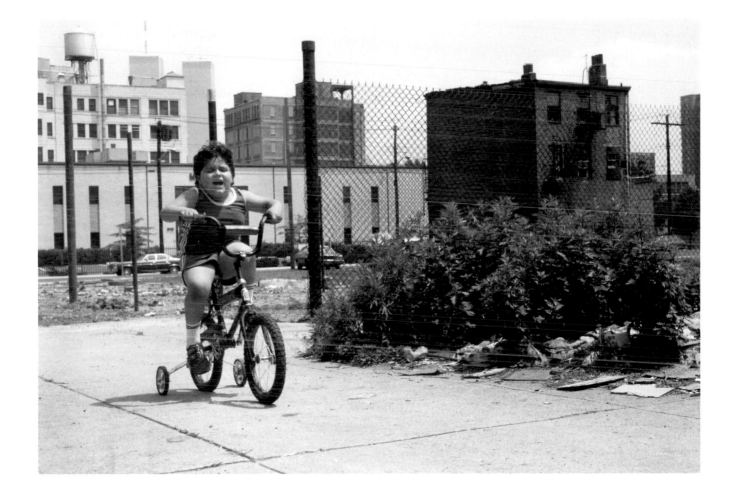

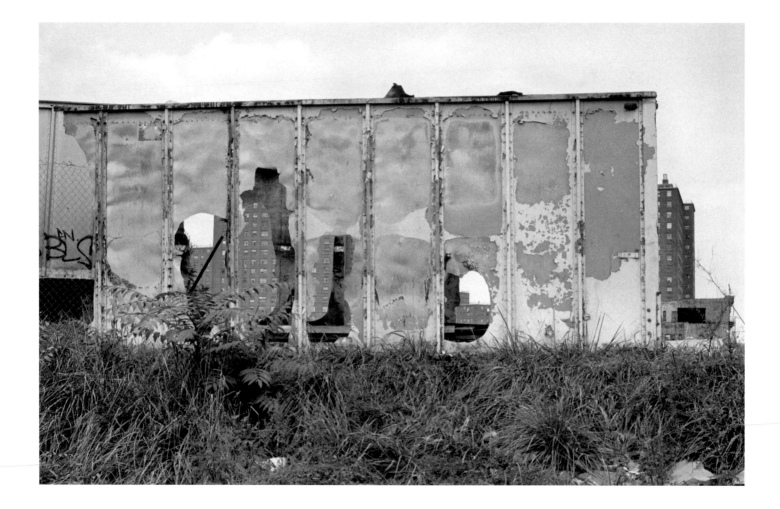

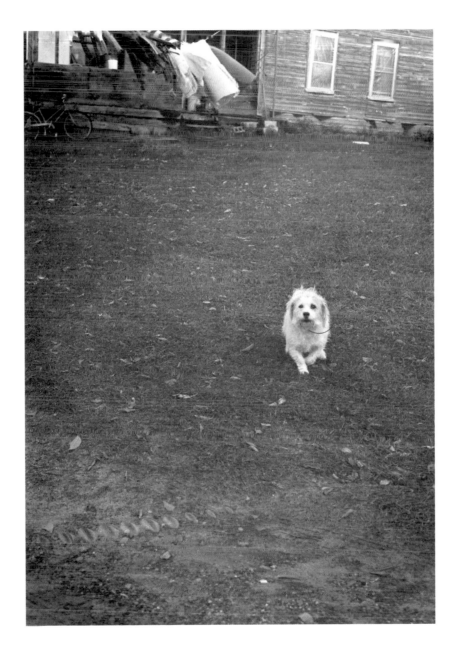

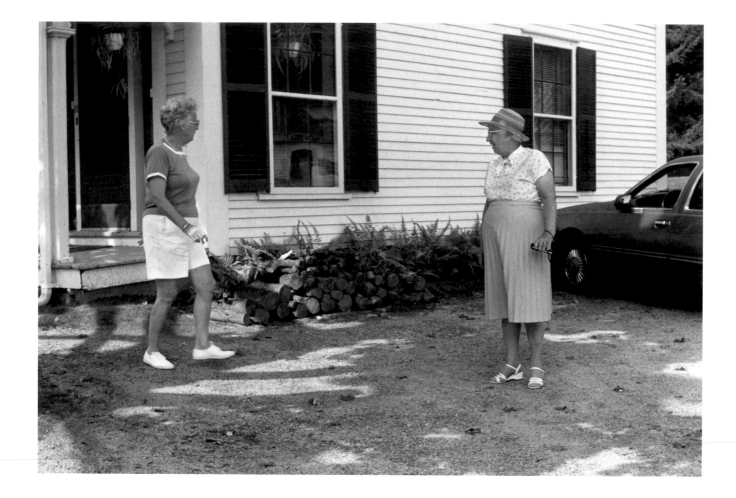

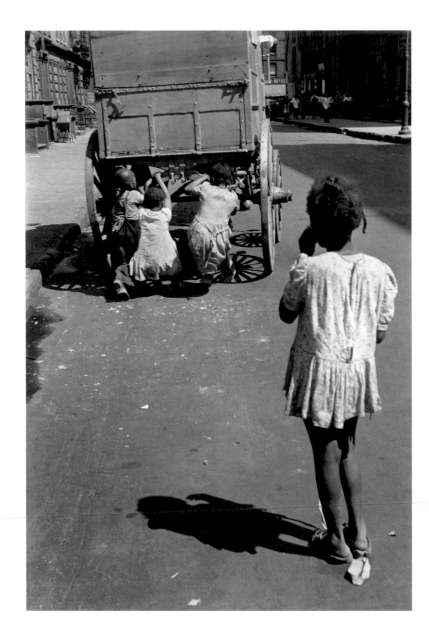

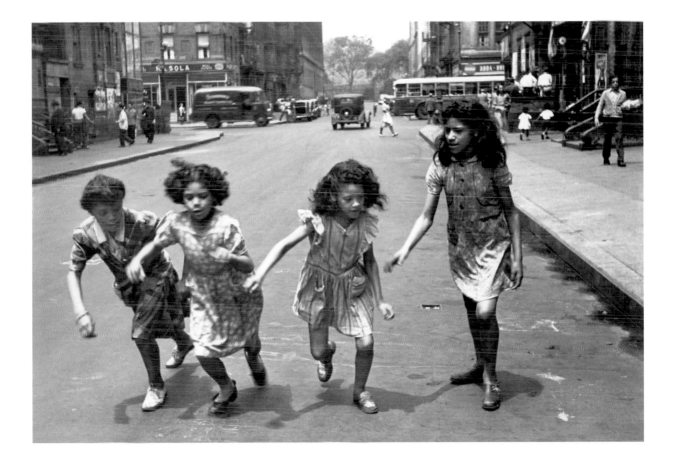

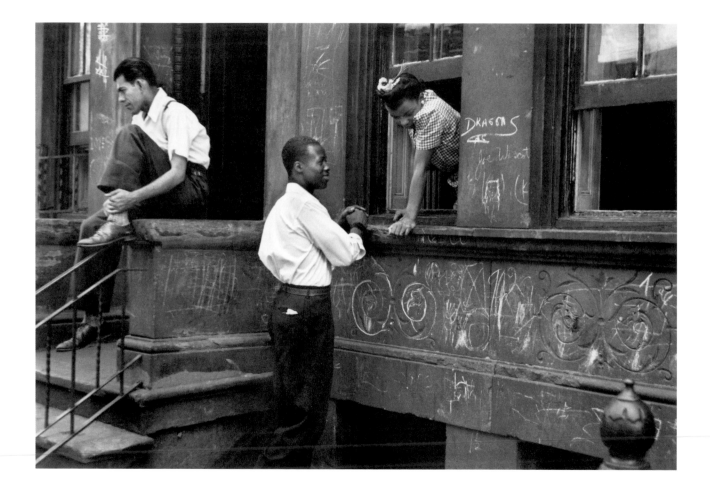

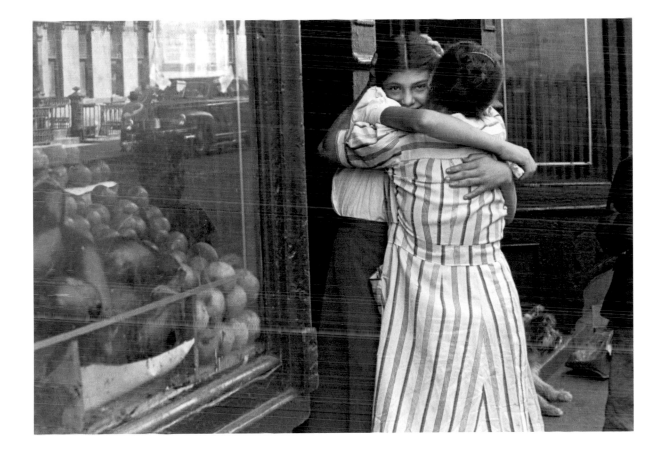

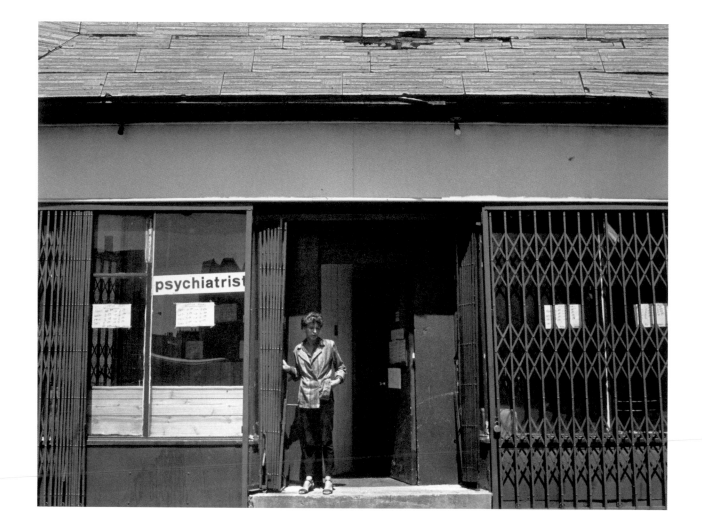

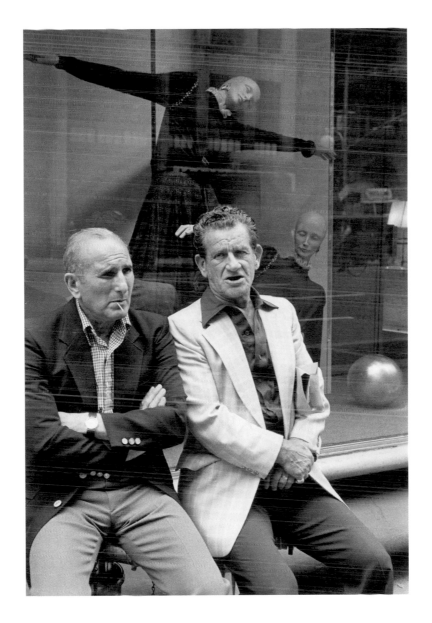

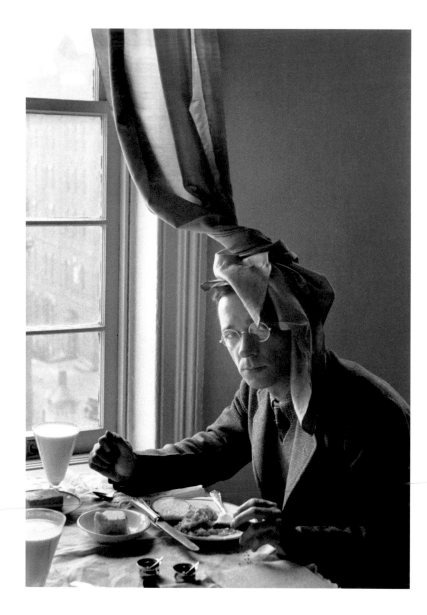

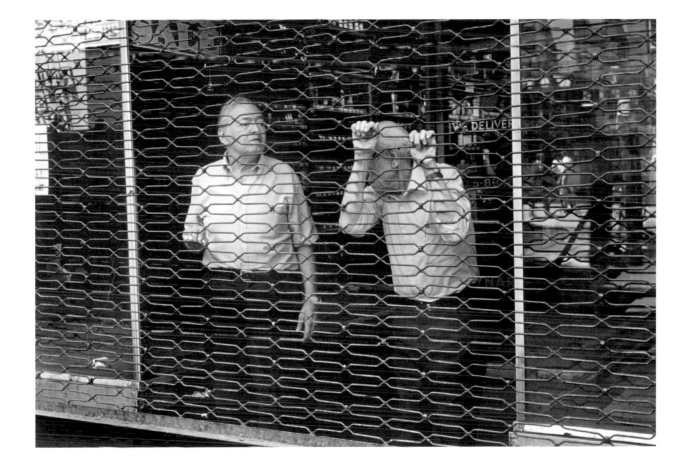

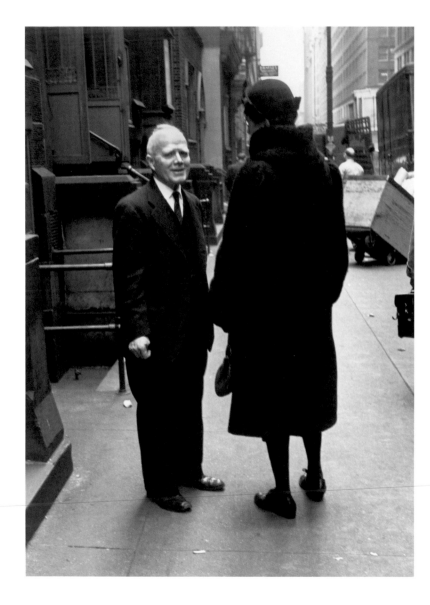

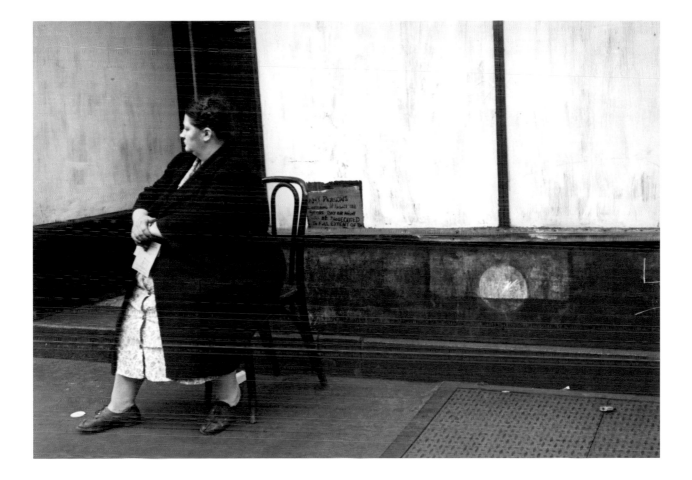

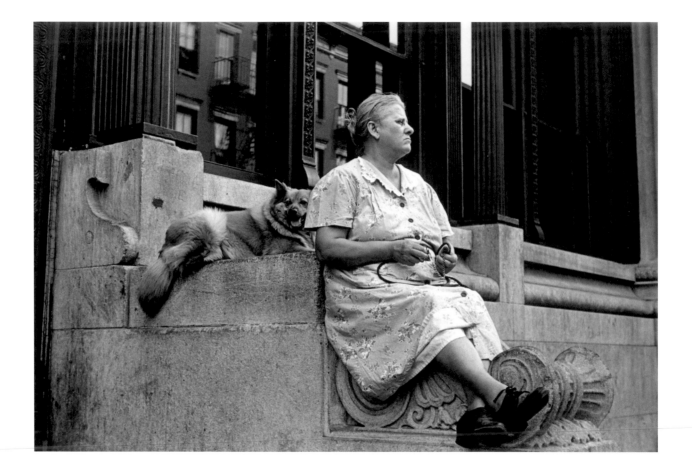

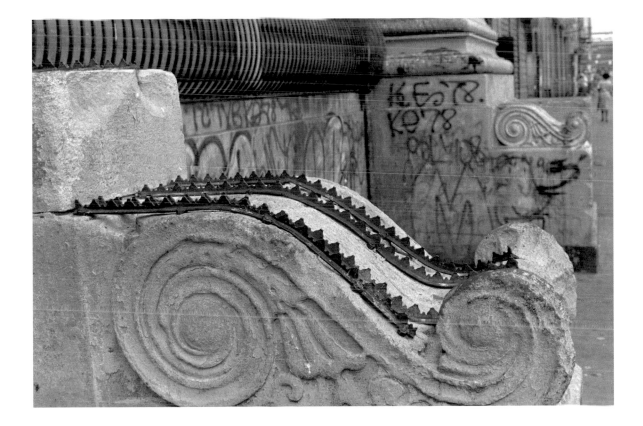

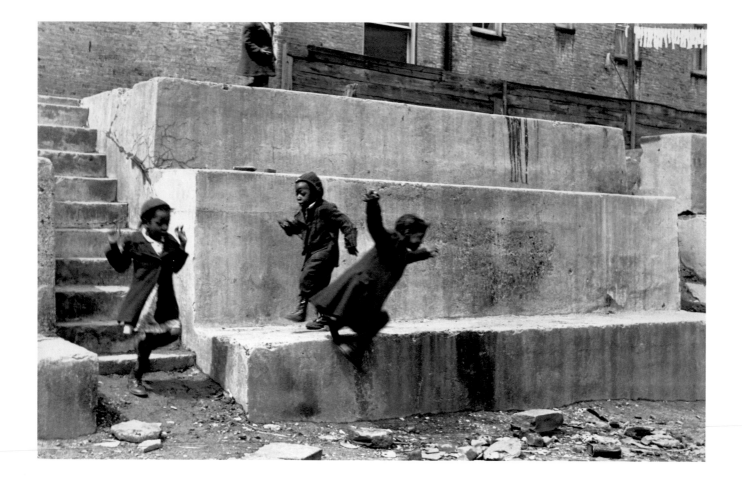

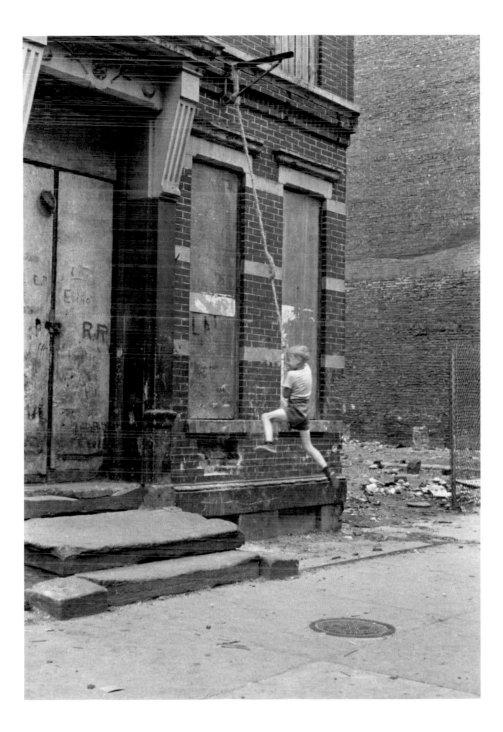

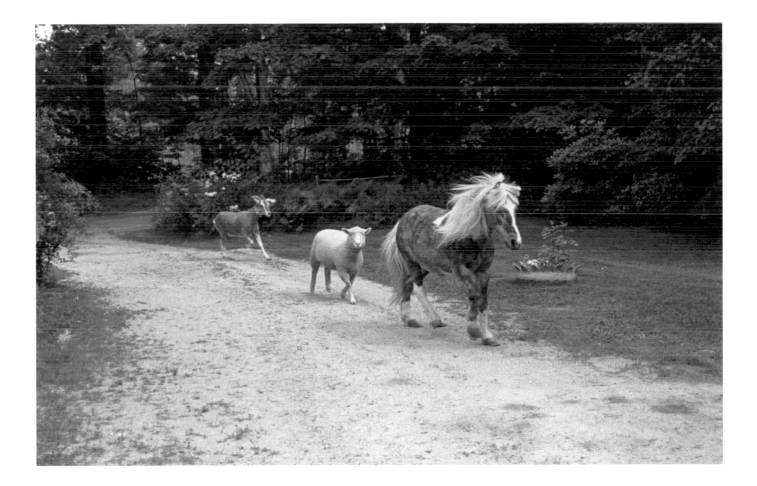

HERE AND THERE

———

© 2003 POWERHOUSE CULTURAL ENTERTAINMENT, INC.

PHOTOGRAPHS © 2003 HELEN LEVITT · FOREWORD © 2003 ADAM GOPNIK

———

PUBLISHED IN THE UNITED STATES BY POWERHOUSE BOOKS, A DIVISION OF POWERHOUSE CULTURAL ENTERTAINMENT, INC.

180 VARICK STREET, SUITE 1302, NEW YORK, NY 10014-4606 · TELEPHONE: 212 604 9074

FAX: 212 366 5247 · EMAIL: HEREANDTHERE@POWERHOUSEBOOKS.COM · WEBSITE: WWW.POWERHOUSEBOOKS.COM

———

FIRST EDITION 2003

LIBRARY OF CONGRESS CATALOGING-IN-PUBLICATION DATA

Levitt, Helen.

Here and There / photographs by Helen Levitt ; foreword by Adam Gopnik. — 1st ed.

p. cm.

ISBN 1-57687-165-7

1. Street photography — New York (State) — New York. 2. Levitt, Helen. I. Title

TR659.8 .L49 2003

779'.99747'1—dc21 2002193057

HARDCOVER ISBN 1-57687-165-7

A COMPLETE CATALOG OF POWERHOUSE BOOKS AND LIMITED EDITIONS IS AVAILABLE

UPON REQUEST; PLEASE CALL, WRITE, OR VISIT OUR WEBSITE.

———

TRITONE REPRODUCTIONS BY THOMAS PALMER

PRINTED AND BOUND IN GERMANY BY STEIDL · GÖTTINGEN

GRAPHIC DESIGN BY MARVIN HOSHINO

—

2 4 6 8 10 9 7 5 3 1